UR ⚡ EYES

BRITTANY WRIGHT

LITTLE, BROWN AND COMPANY

NEW YORK BOSTON LONDON

Little, Brown and Company
Hachette Book Group
1290 Avenue of the Americas, New York, NY 10104
littlebrown.com

First Edition: November 2017

Little, Brown and Company is a division of Hachette Book Group, Inc. The Little, Brown name and logo are trademarks of Hachette Book Group, Inc.

The publisher is not responsible for websites (or their content) that are not owned by the publisher.

The Hachette Speakers Bureau provides a wide range of authors for speaking events. To find out more, go to hachettespeakersbureau.com or call (866) 376-6591.

Photography by Brittany Wright

Jacket and interior design by Laura Palese

ISBN 978-0-316-27578-1
LCCN 2017935289

10 9 8 7 6 5 4 3 2 1

LSC-C

Printed in the United States of America

TO
SUSU & PAPA,
MY
GRANDPARENTS

I MAKE ART WITH FOOD.

I was raised in San Diego by my grandparents, a couple of Cajuns for whom food was everything. They introduced me to their Southern roots with the flavors of okra, gumbo, and grits—all of which seemed exotic to my elementary school classmates. I wondered: if the foods I ate every day were a revelation to my friends, what other new things could I show the world?

My grandma wasn't a professional photographer, but she showed me how special it was to pause and save memories—like we did on a monthlong road trip down Baja California when I was five, living the dream of eating tacos for every meal. When I was given my own camera at age eleven, photography became my life. I began to think creatively, to see the world through a frame that was as mobile as my camera viewfinder. Taking the time to watch how light reflects through glass, or to find the patterns in shadows, awoke a passion for using only natural light in my images.

I took these experiences straight to corporate America, where a day job repairing computers started to eat all my creative energy and left me feeling depleted. The days began to feel like a colorless blur: go to work, come home, sleep, wake up, repeat. I needed something to get excited about again. I considered going to rally-car school and living out my racing dreams but eventually chose a more practical (and less dangerous) option. I decided to teach myself how to cook.

Like any beginner, I jumped from recipe to recipe, collecting techniques from a stack of cookbooks. As I became more experienced, I found myself getting more inspired by the beauty of the ingredients than by the final dish I put on the table. I started shopping at farmers' markets and getting to know the people who grew my food. Along the way, I saw things like the delicious variety of colors that carrots can be—and realized I could connect my love for light and color with food.

I began a new project in which, unlike food blogs that showcase the end result of a recipe, I would photograph the ingredients at the beginning: as *mise en place,* how they looked before step one in the recipe. My eyes were drawn to how the

naturally occurring shapes fit together, along with the patterns they were capable of making. When I created my first image with a gradient of color flowing across my ingredients, I felt like I had opened a treasure chest.

Without knowing it, I was creating the concept behind this book: using photography to tell a story about our food that changes the way we see it. I hope these images get you to slow down, take a breath, and marvel at the gorgeous abundance we can create from the earth.

In this book, you will find what I love about the magic of food. These images showcase not only the brilliant colors of our produce but also their varied textures and sizes, and how they change throughout their growth.

My goal for the future is to help communities appreciate the beauty of the ingredients we see every day. That beauty is the final product of a lot of hard work, and connecting with our food and those who grow and cook it is meaningful. As more and more people have found my #foodgradients on Instagram,

I've had the opportunity to meet and learn from chefs, food producers, and farmers around the country. Their passion inspires my work.

The ingredients for each image were sourced at local farms, farm stands, and grocery stores, and styled in my studio. (I have definitely been known to bring out a cashier's knowledge of produce SKUs as a party trick! And I'll take any excuse to buy more than a hundred doughnuts at a time.)

Creating art is my way of using the power of food and art to bring people together, to calm, and to comfort. I hope these images bring a smile to your face and inspire you to bring some of these foods home and create a meal. I have given my imagination a home in these pages, and I hope you have as much fun inside this book as I did creating it for you.

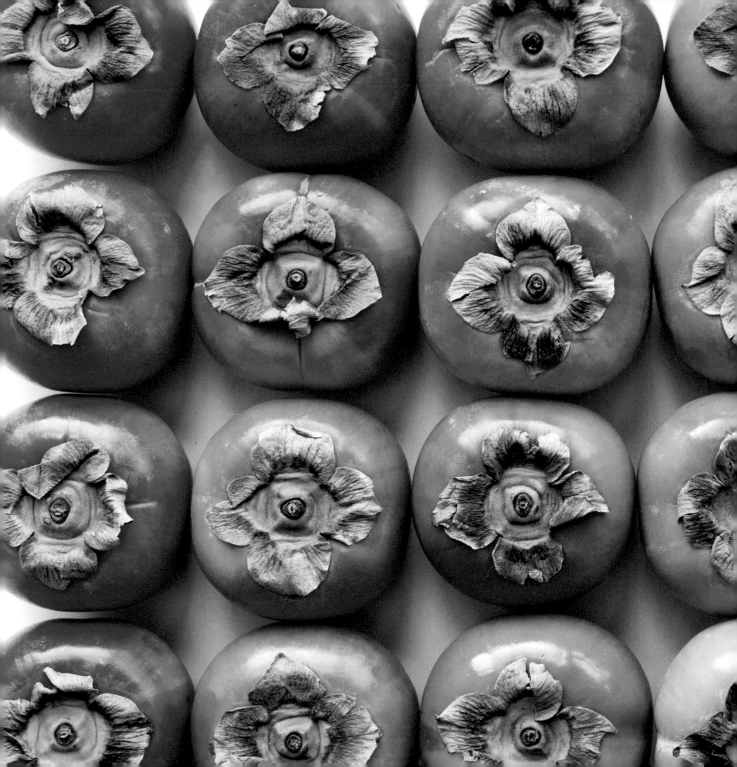

PERSIMMONS

There are two main types of persimmons: Fuyu persimmons (pictured) are non-astringent, which means you can eat them even when they feel hard to the touch. They are delicious raw and will stay fresh for up to three weeks. Hachiya persimmons, which are shaped like acorns, have an unpleasantly astringent taste before they're soft and ripe. They stay fresh for only a few days and are mostly used for cooking.

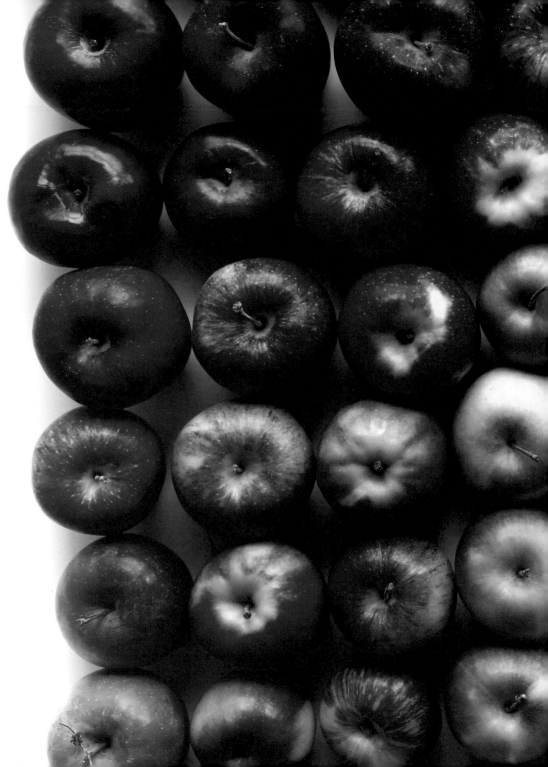

APPLES

There are more than 7,500 varieties of apple growing around the world. We've spent three thousand years cultivating the best apples for cooking, making cider, and eating raw.

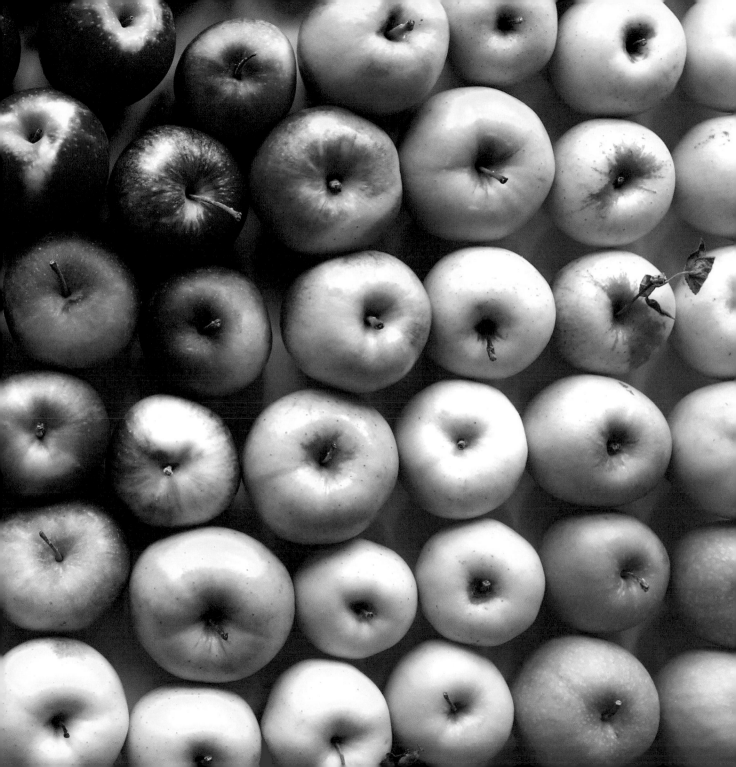

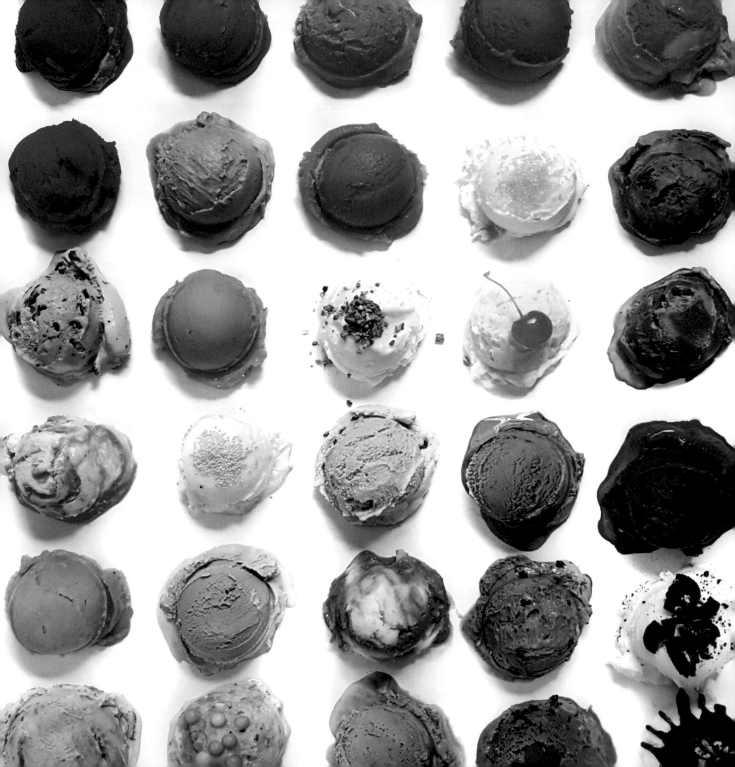

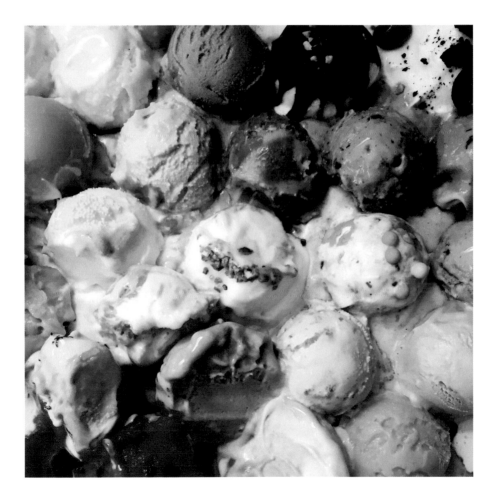

opposite **ICE CREAM** / *this page* **MELTED ICE CREAM**

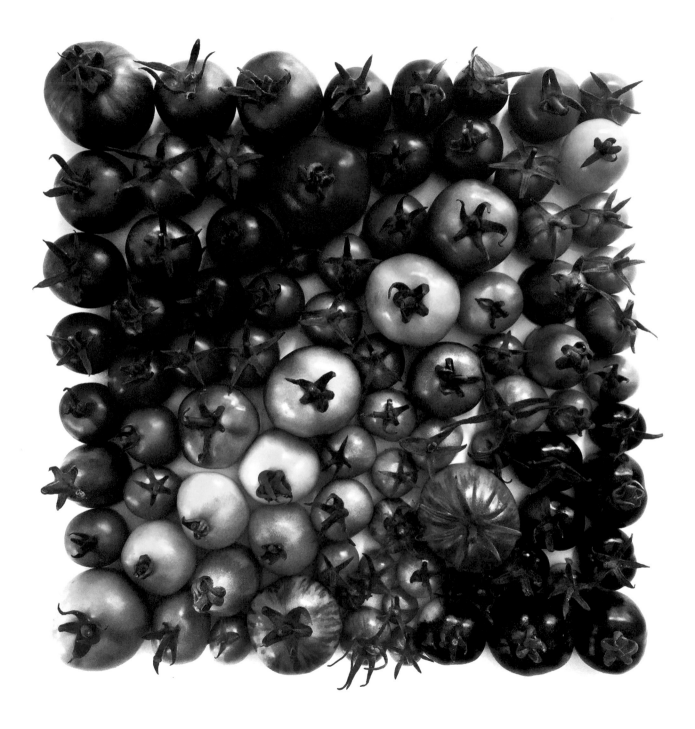

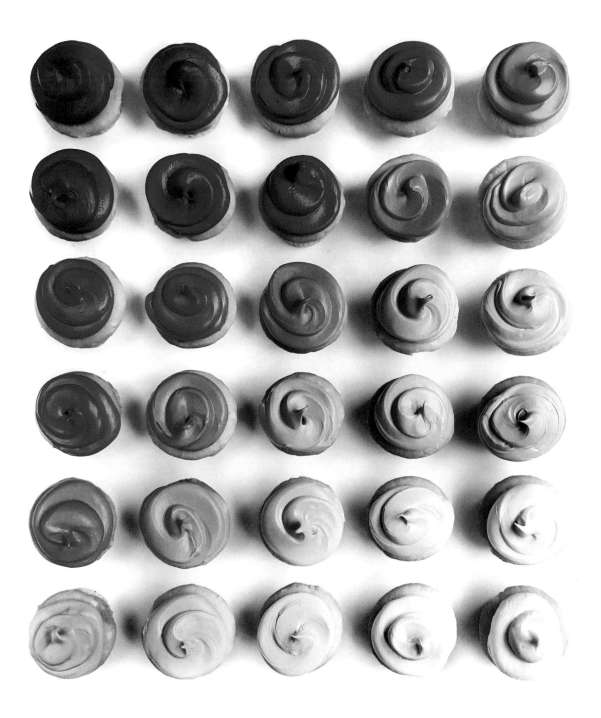

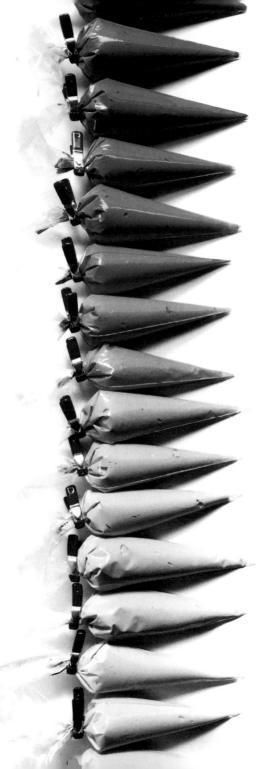

WINE

All the colors in white, rosé, and red

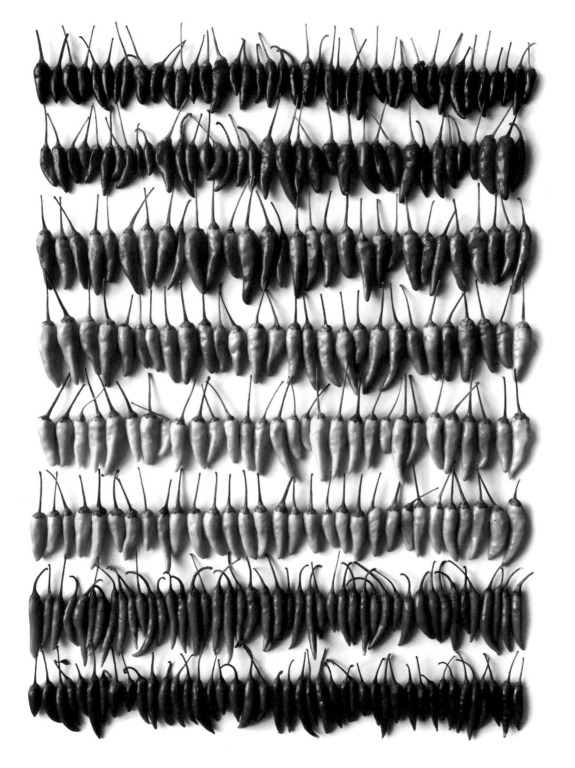

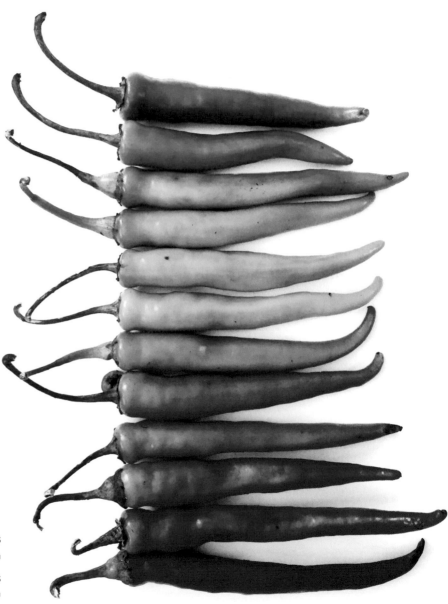

opposite **THAI CHILIES**
Most ripe to least ripe, top to bottom

this page **CAYENNE PEPPERS**
Least ripe to most ripe, top to bottom

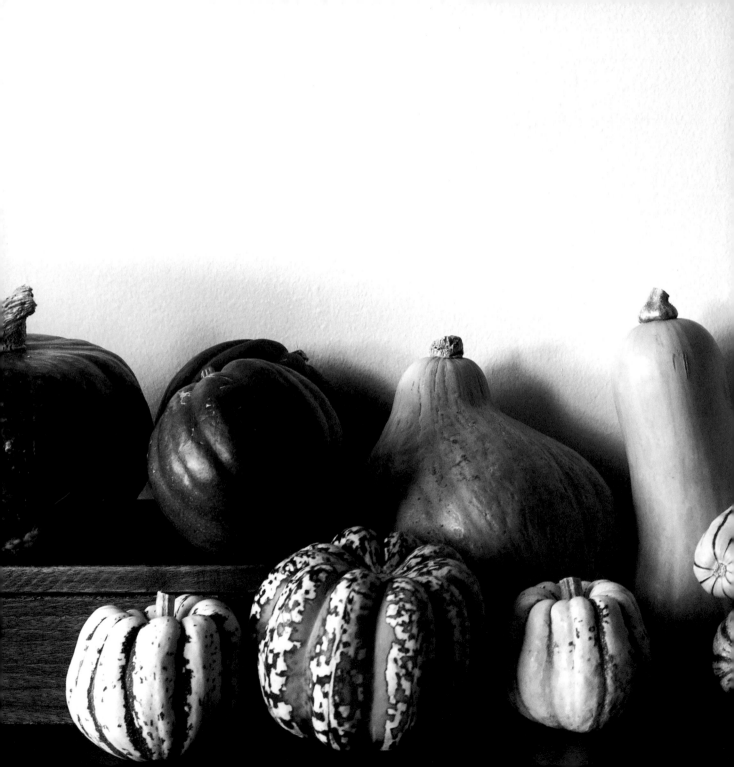

WINTER SQUASH

From left kabocha squash / sweet dumpling squash /
acorn squash / carnival squash / blue Hokkaido pumpkin
/ butternut squash / delicata squash / spaghetti squash
/ sugar pie pumpkin / red kuri squash

SUGARS

From left dark brown / palm / muscovado /
coconut / turbinado / brown slab / pearl /
light brown / pure cane / granulated white /
confectioner's / nib / baker's sugars

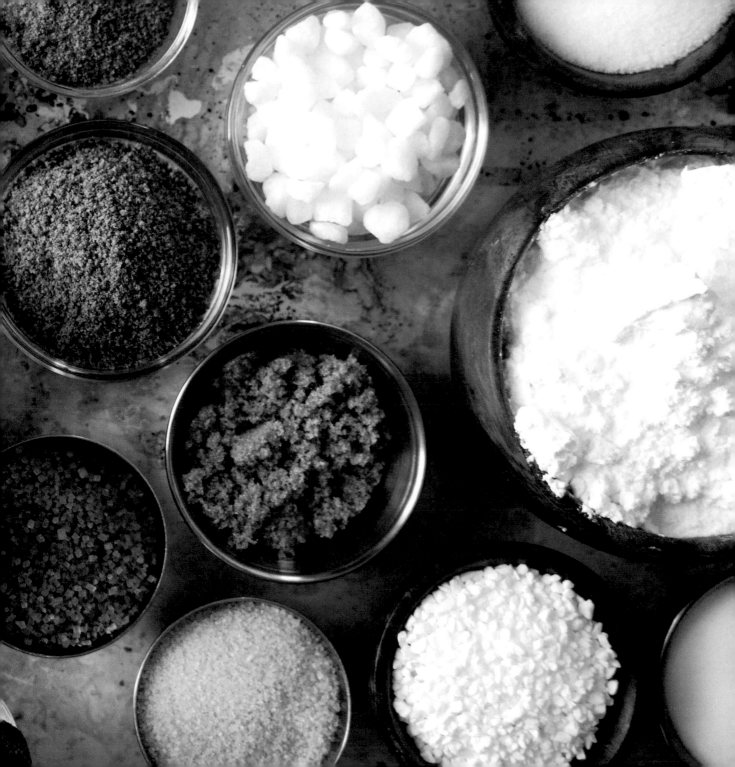

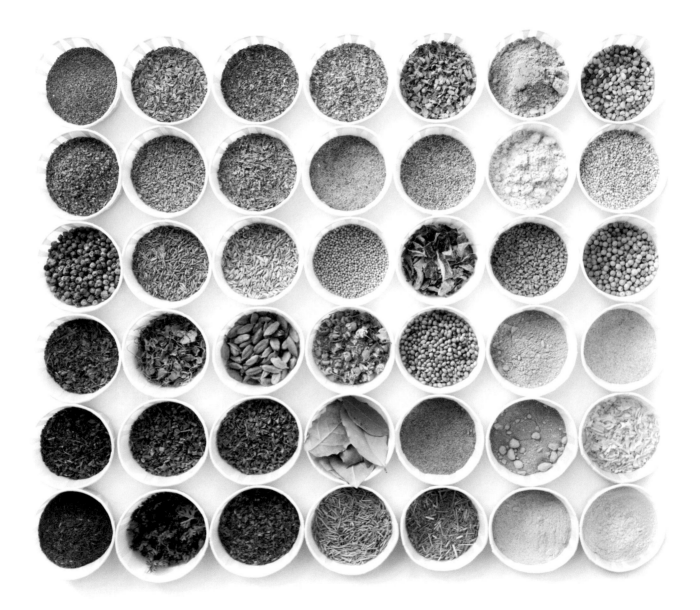

SPICES

Left to right, top to bottom celery seed / dill seed / basil / Turkish oregano / Mexican oregano / ginger powder / mahlab / marjoram / anise seed / epazote / dill pollen / fennel pollen / mustard powder / roasted sesame seed / green peppercorn / cumin seed / fennel seed / yellow mustard seed / lemon peel / fenugreek seed / white peppercorn / tarragon / fenugreek leaf / green cardamom pods / chamomile / Indian coriander seed / amchoor / garlic granules / peppermint / chives / lemon thyme / bay leaf / celery salt / molasses / onion flake / dill / parsley / chervil / rosemary / lemongrass / white pepper / garlic powder

⚡

SPICES

Left to right, top to bottom turmeric / African cayenne / Thai chili / Aleppo pepper / beet powder / annatto seed / lavender / mace / Indian cayenne / Chinese chili / pink peppercorn / sun-dried tomato / rose / poppy seed / mace blades / piment d'Espelette / smoked sweet paprika / pequin / Szechuan pepper / brown mustard seed / juniper berry / habanero flake / orange peel / star anise (ground) / ancho chili / sumac / black Tellicherry peppercorn / black sesame seed / nutmeg (ground) / cassia cinnamon chip / cinnamon stick / grains of paradise / cardamom seed / cloves / black lemon / nutmeg (whole) / European coriander seed / black cardamom pods / star anise / long pepper / chipotle chili flake / nigella seed

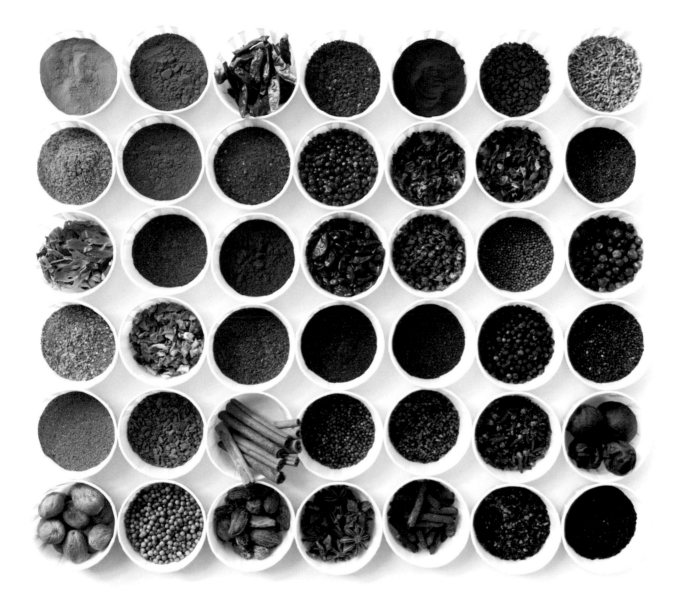

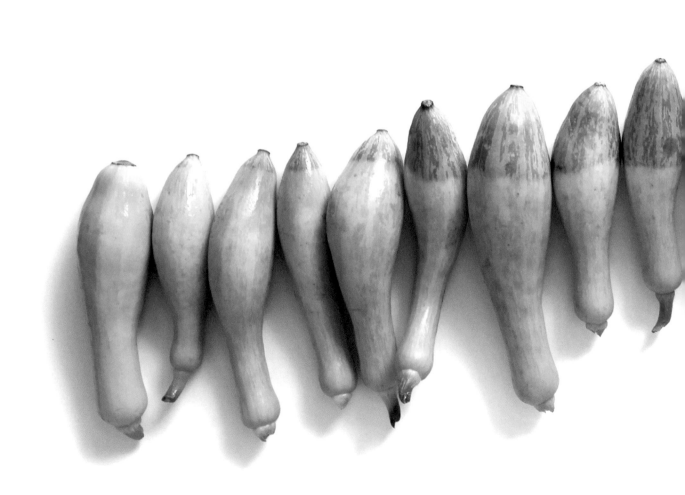

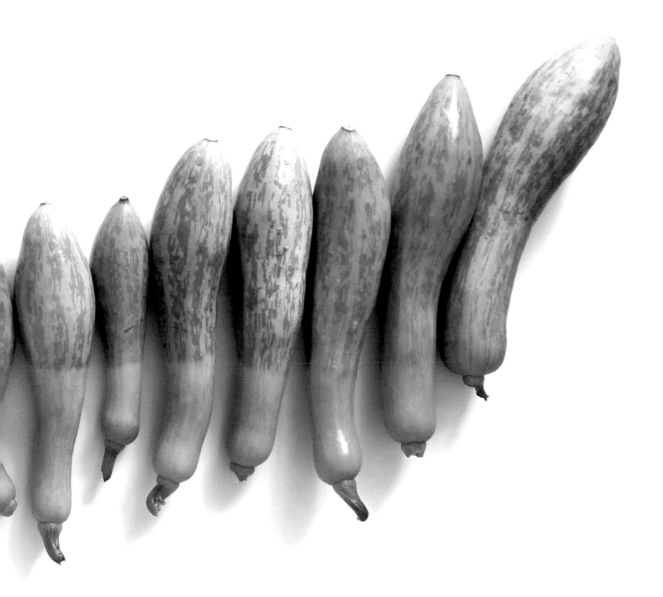

SUMMER SQUASH

Zephyr squash grown on Local Roots Farm,
in Duvall, Washington

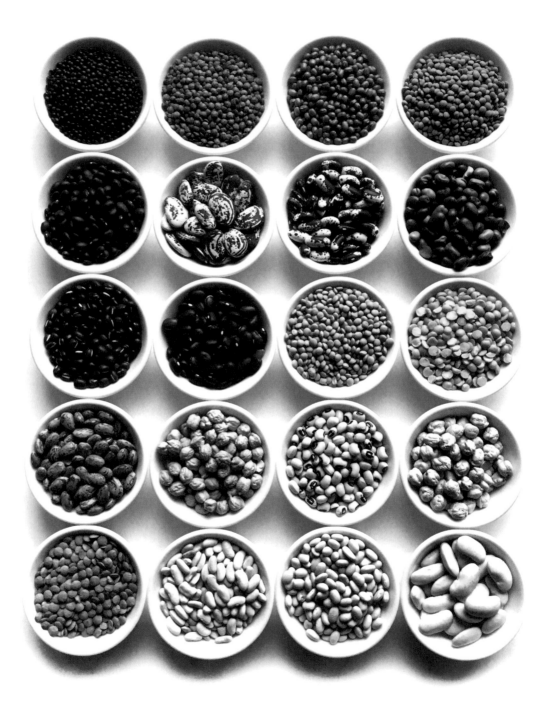

PULSES

Left to right, top to bottom black turtle beans **/** Puy lentils **/** mung beans **/** brown lentils **/** black beans **/** cranberry beans **/** Anasazi beans **/** fava beans **/** adzuki beans **/** red kidney beans **/** red lentils **/** yellow split peas **/** pinto beans **/** chickpeas **/** black-eyed peas **/** chickpeas **/** green lentils **/** flageolet beans **/** cannellini beans **/** lima beans

LENTILS

From left brown / red / yellow / green (French) / Puy / beluga

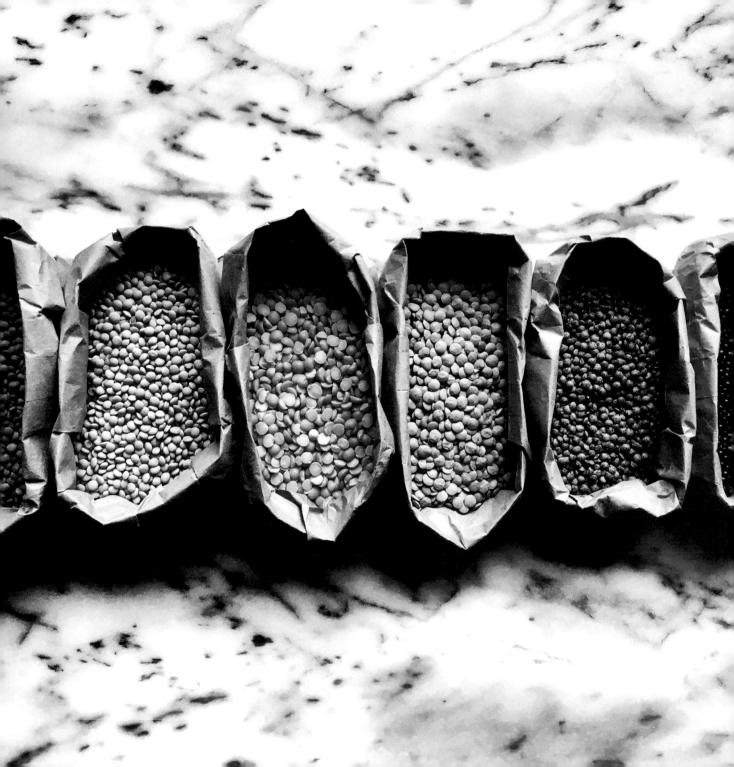

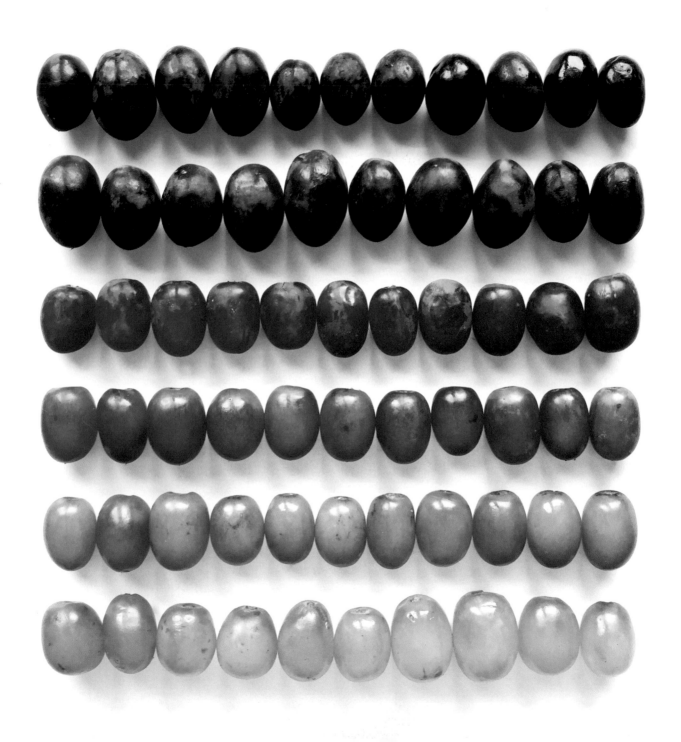

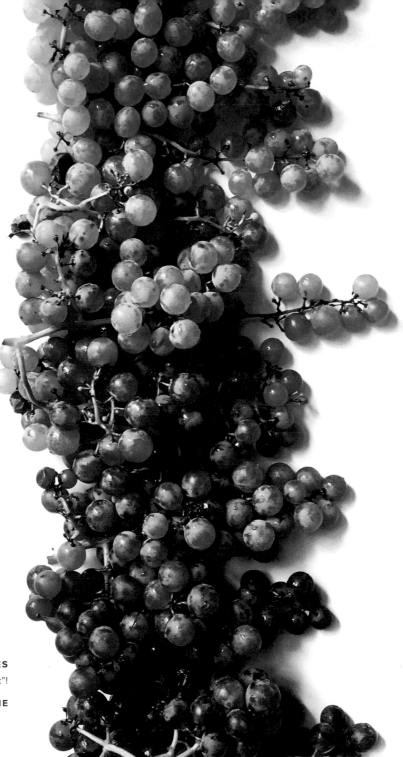

opposite **GRAPES**
It's a "grape-dient"!

this page **GRAPES ON THE VINE**

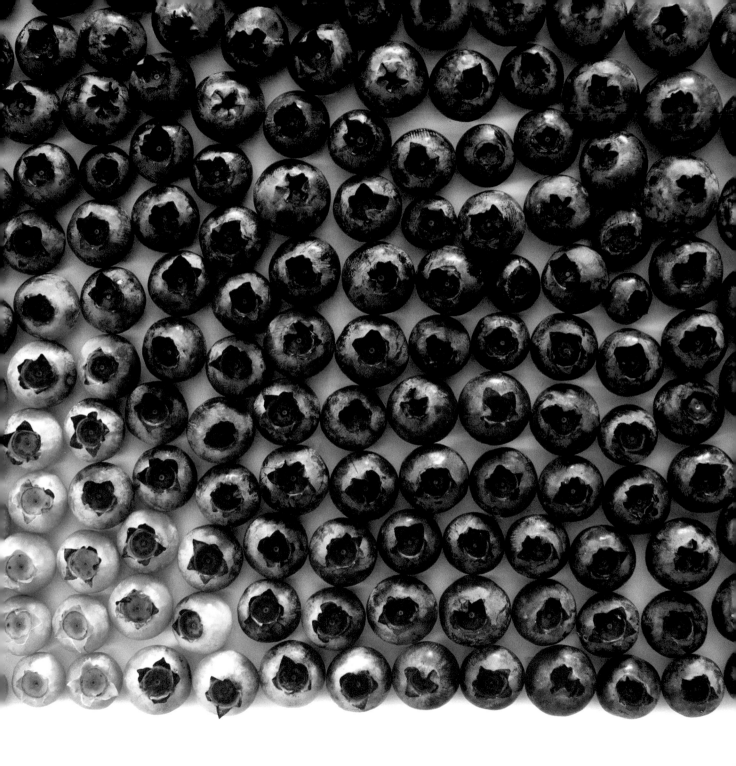

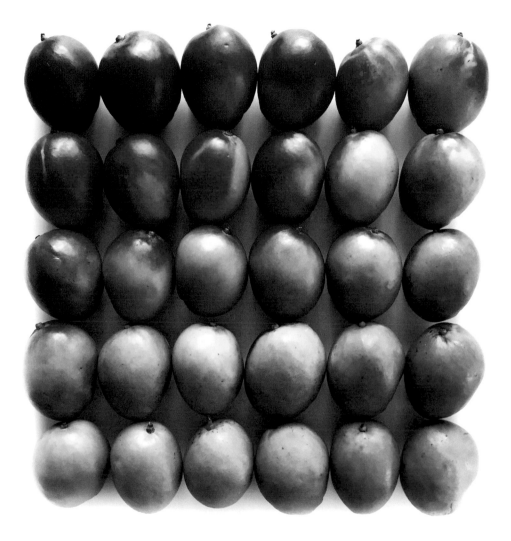

this page **MANGOES** / *opposite* **BLUEBERRIES**

Each of these blueberries was harvested from a friend's
childhood home. As they grow, the berries exhibit a beautiful transition
in color that varies with each type of blueberry plant.

FLOURS

Right to left roasted soybean / coarse cornmeal /
semolina / fine cornmeal / rye / whole wheat / spelt,
/ oat / durum / garbanzo bean / pastry / cake /
buckwheat / all-purpose / potato / sweet rice / tapioca

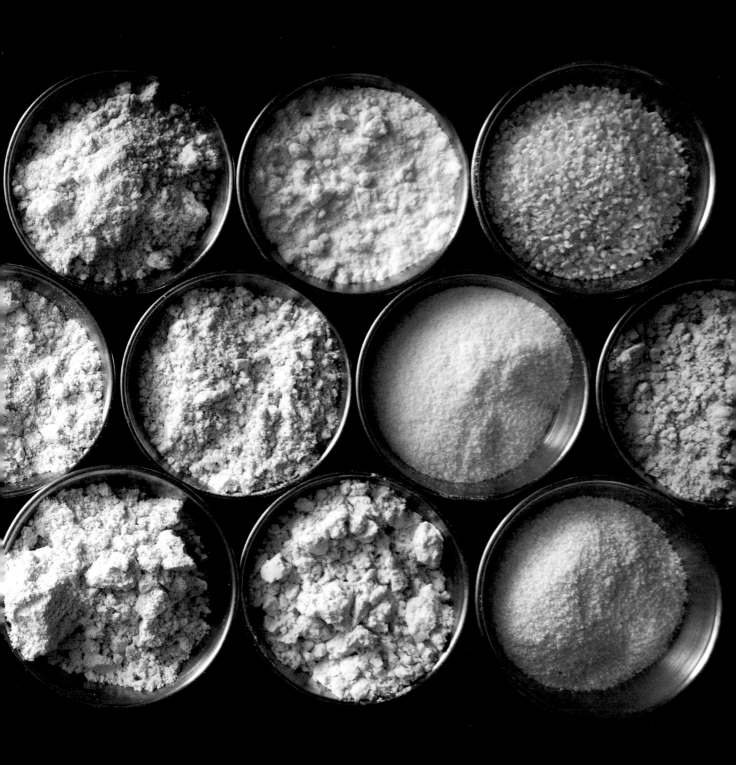

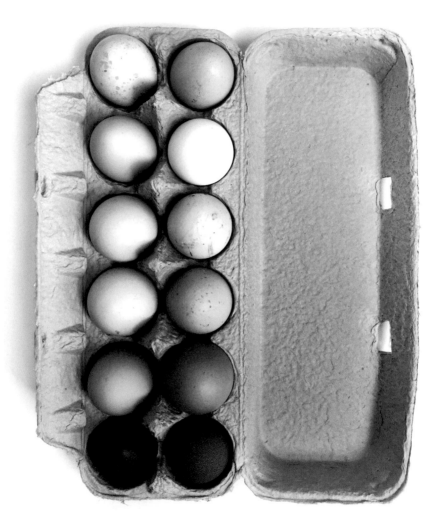

NATURAL CHICKEN EGGS / DYED CHICKEN EGGS

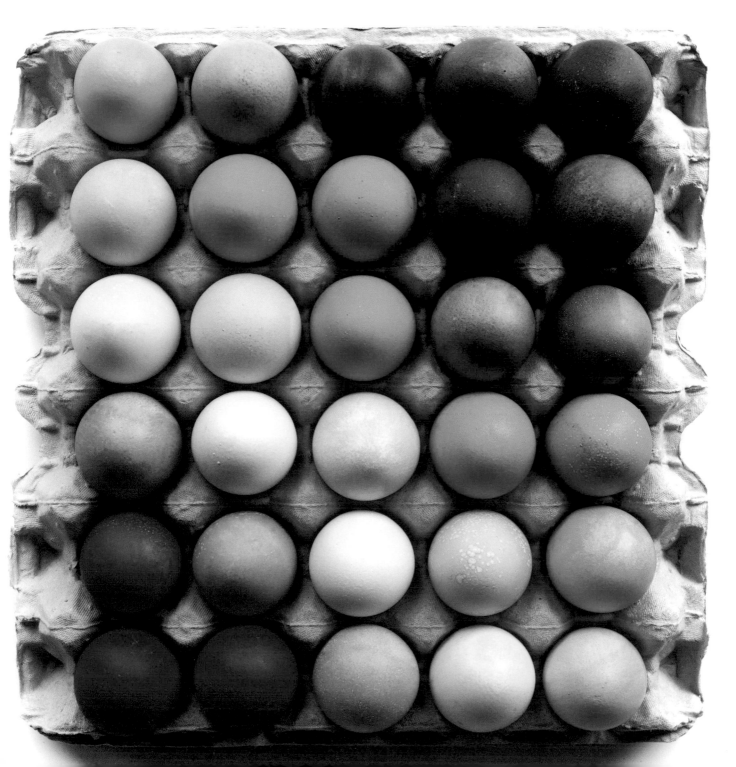

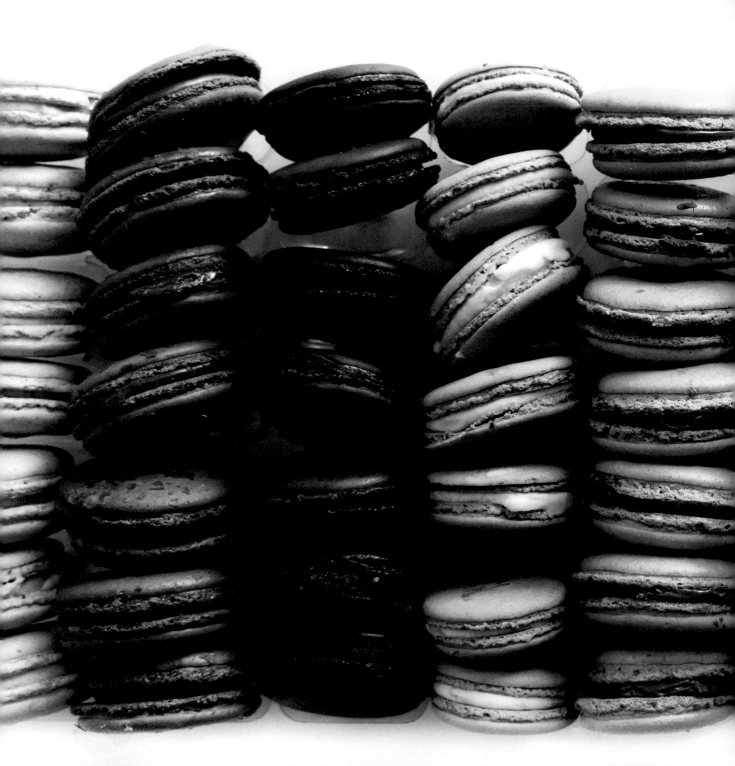

MACAROONS
A photo to show when asked what
you're hungry for

CITRUS

Left to right (and top to bottom) blood oranges **/** pink grapefruit **/**
ruby-red grapefruit **/** Satsuma tangerines **/** honey tangerines **/** kumquats **/**
navel oranges **/** lemons **/** yellow grapefruit **/** limes

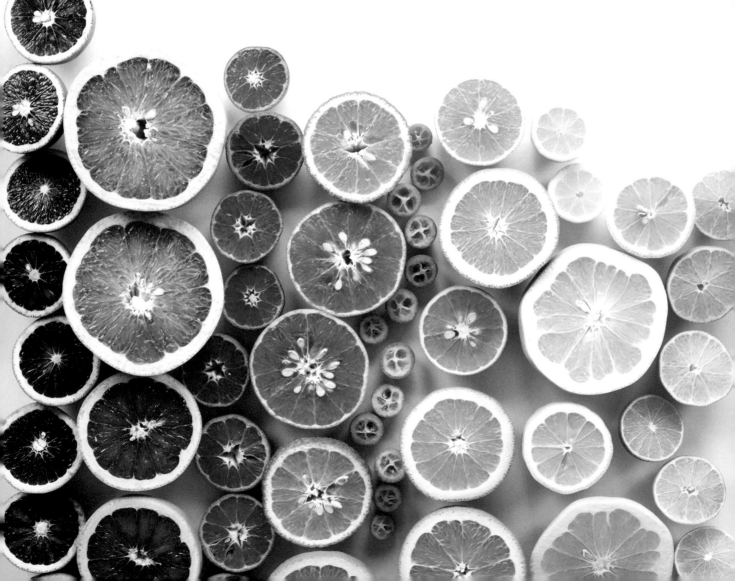

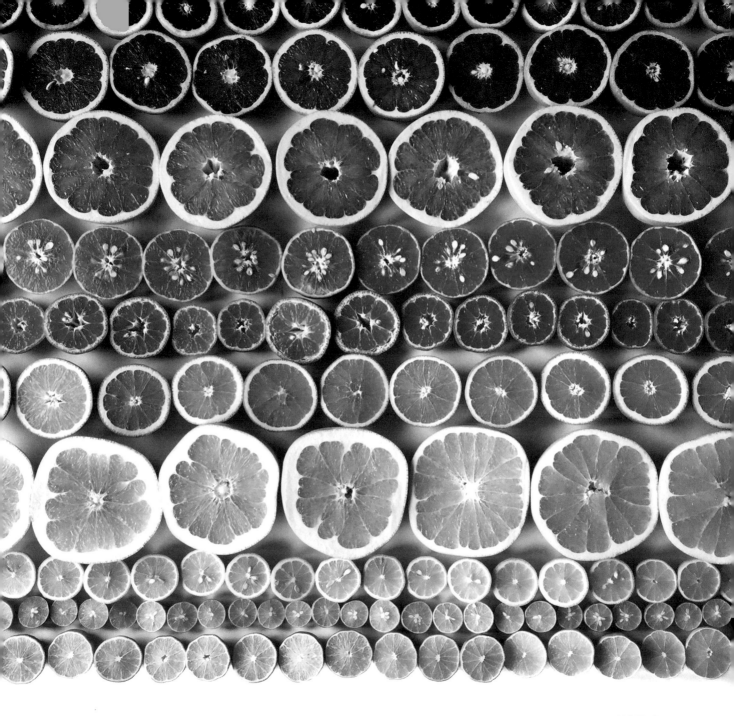

CITRUS JUICES *this page, from left* blood orange **/**
ruby-red grapefruit **/** honey tangerine **/** Satsuma tangerine **/**
yellow grapefruit **/** orange **/** lemon **/** lime

FRUIT JUICES *opposite, from top* pomegranate **/**
apple **/** strawberry **/** carrot **/** orange **/** lemon **/** lime **/** kale **/**
spinach **/** celery **/** cucumber

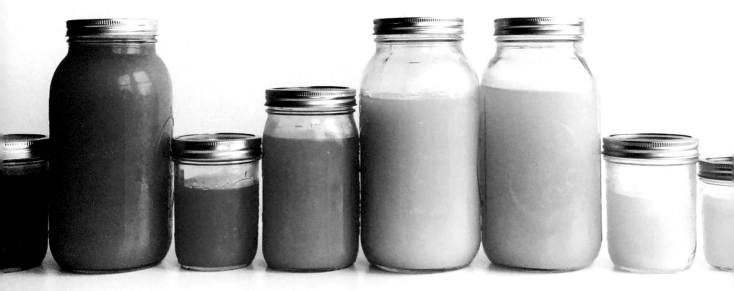

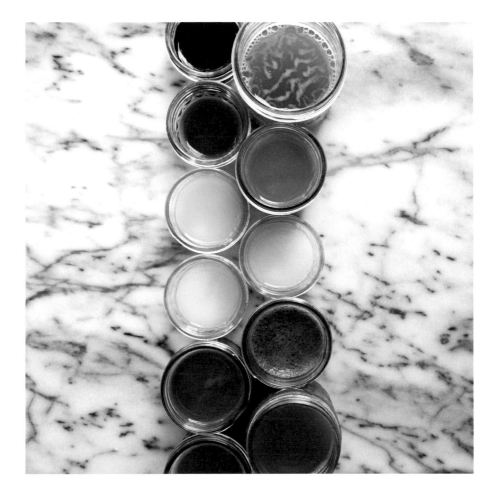

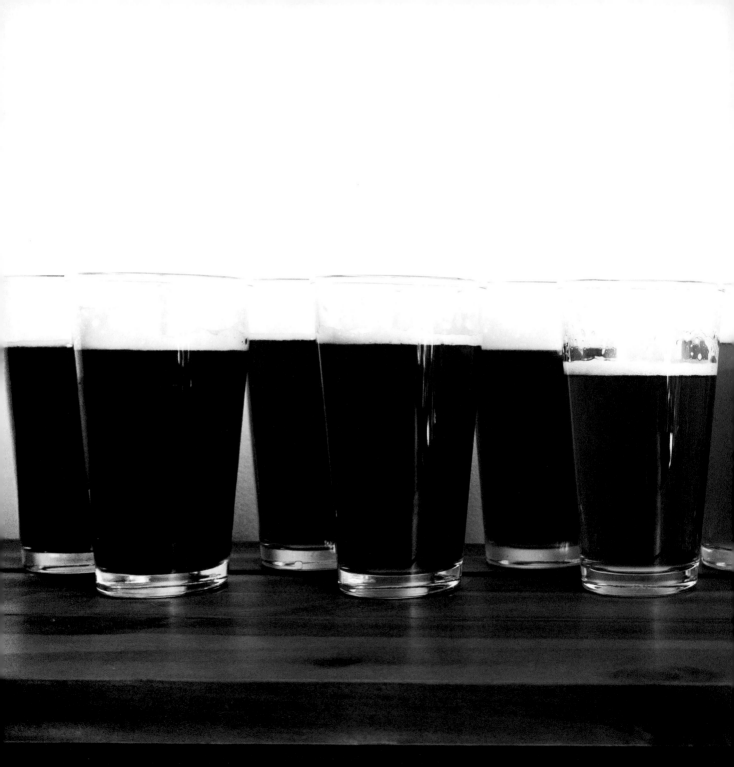

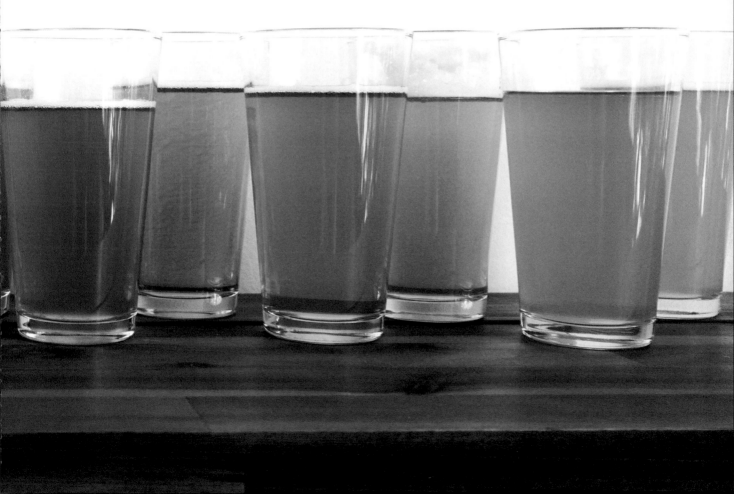

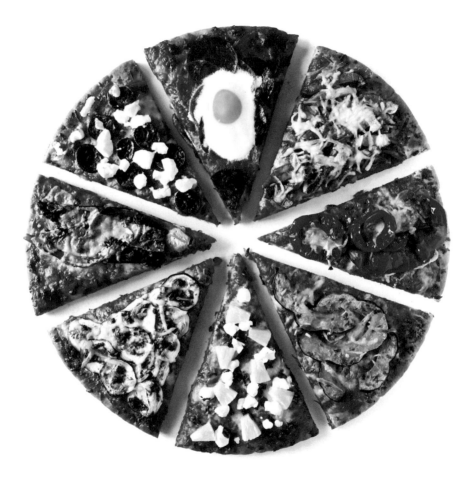

this page **PIZZA** / *opposite* **BREAKFAST CEREALS**

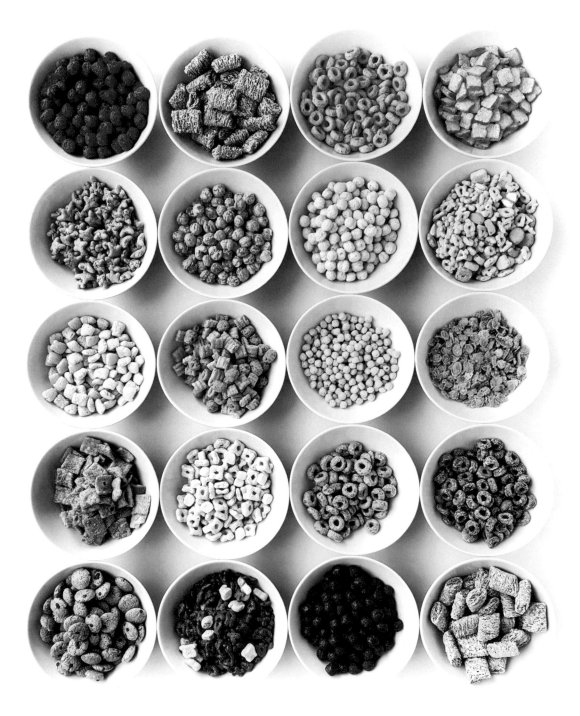

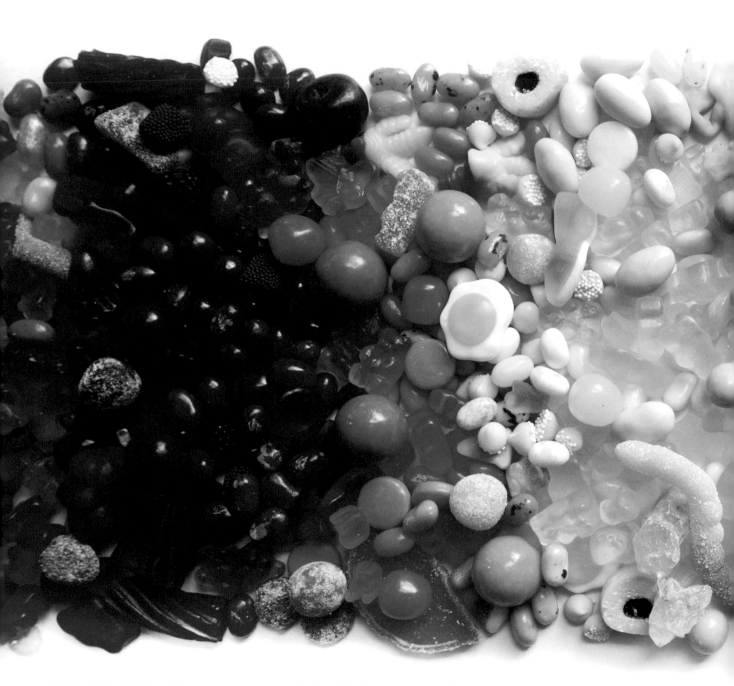

CANDY Candy is dandy, but liquor is quicker (*see pages 18–19 and 50–51*).

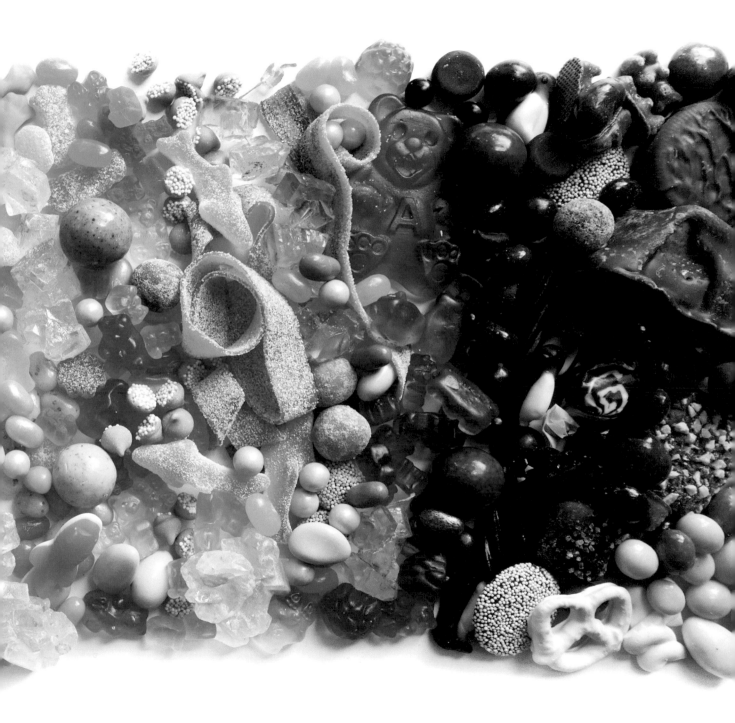

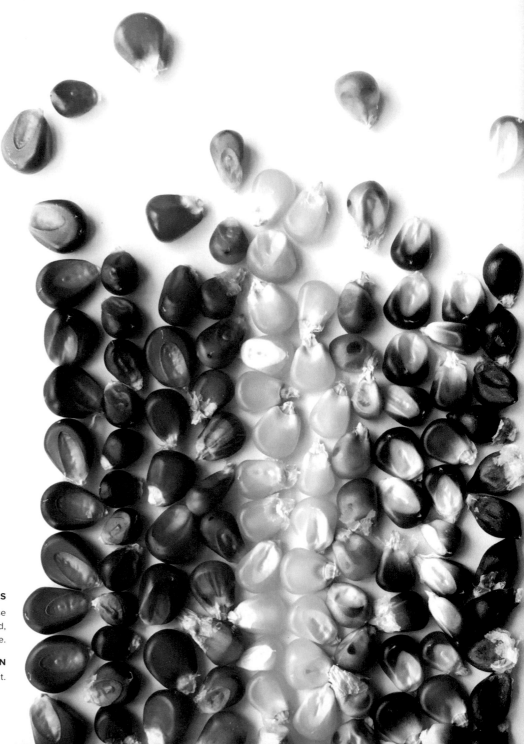

this page **POPCORN KERNELS**
Grown on Oxbow Farm, these
multicolored ears were harvested,
dried, shelled, and sorted by me.

opposite **POPCORN**
Just add heat.

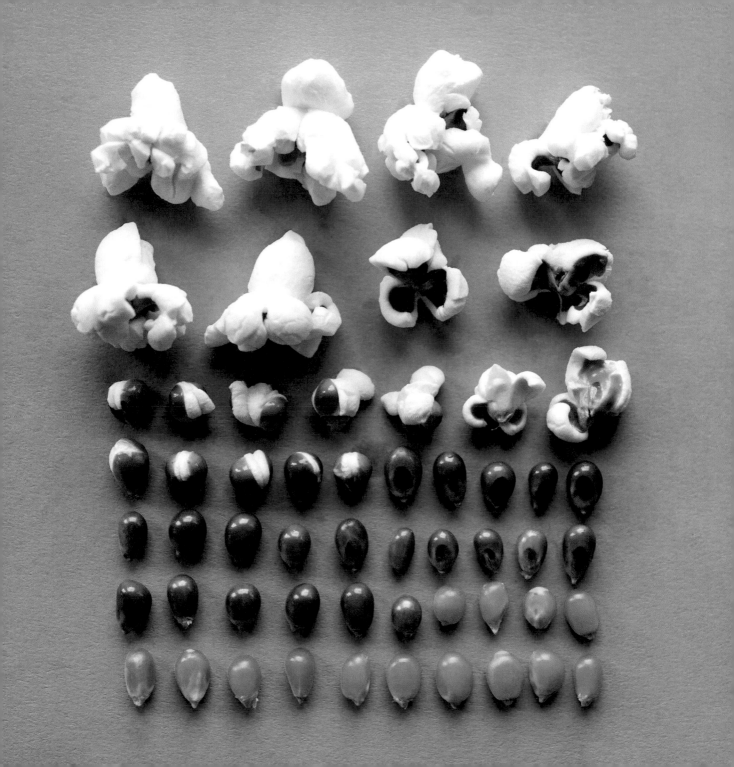

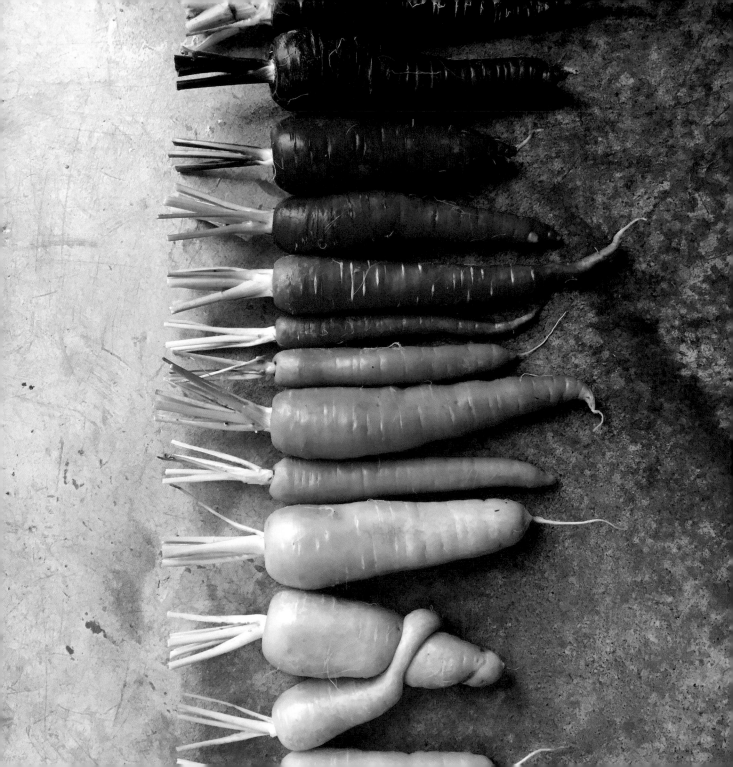

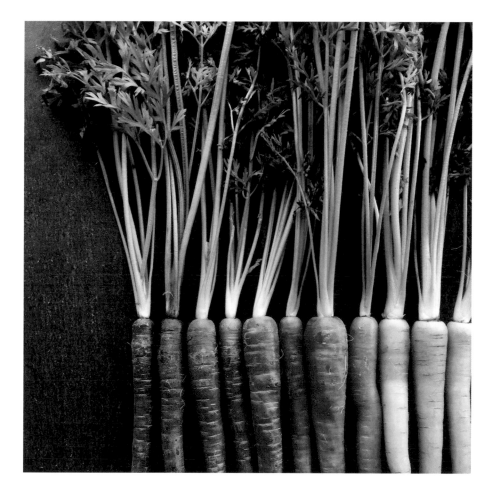

opposite **CARROTS** They're not just orange! / *this page* **MORE CARROTS**

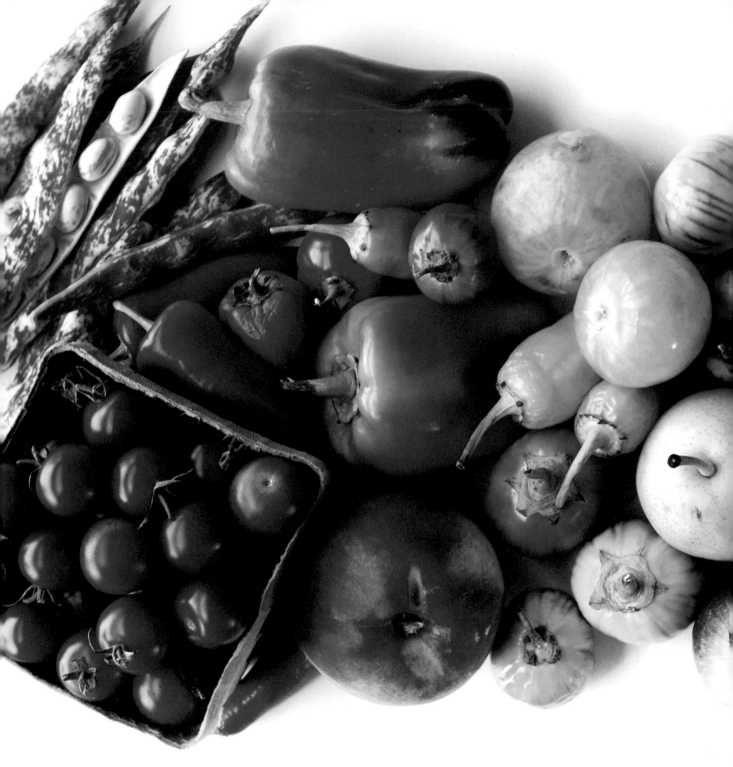

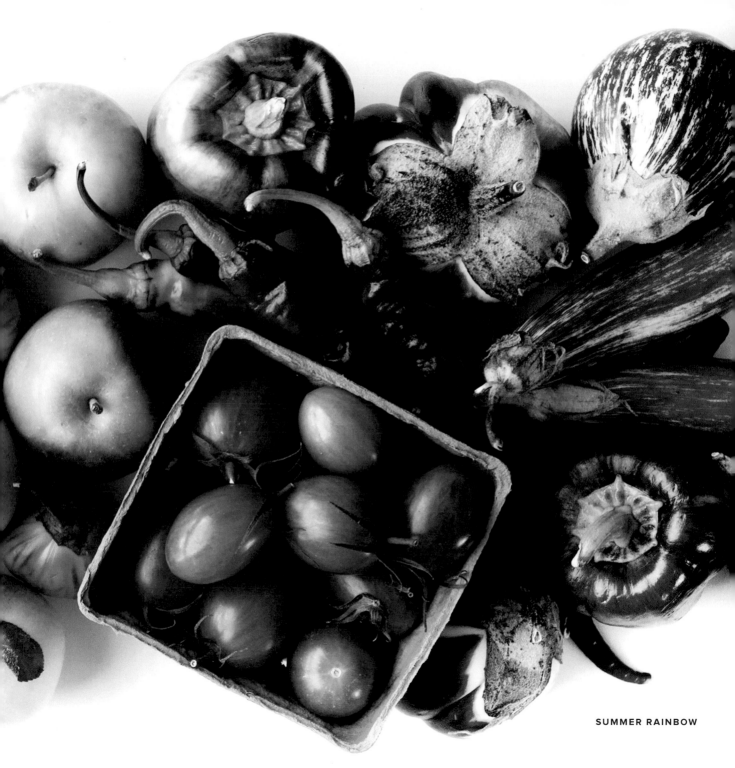

SUMMER RAINBOW

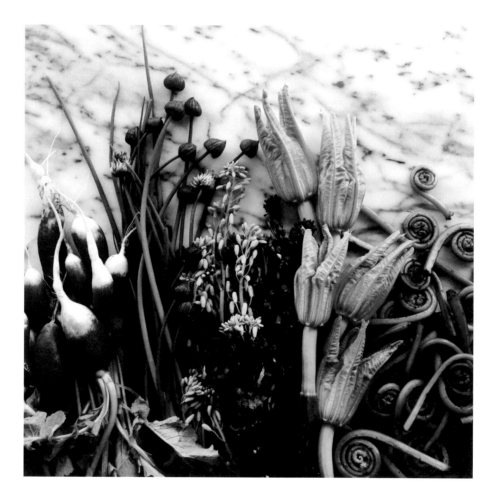

this page **SPRING FAVORITES** / *opposite* **FALL FAVORITES**

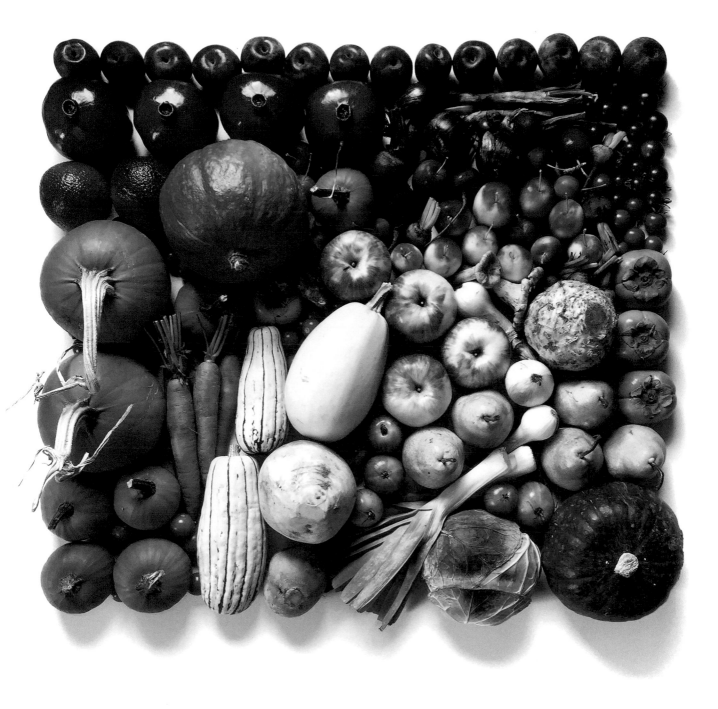

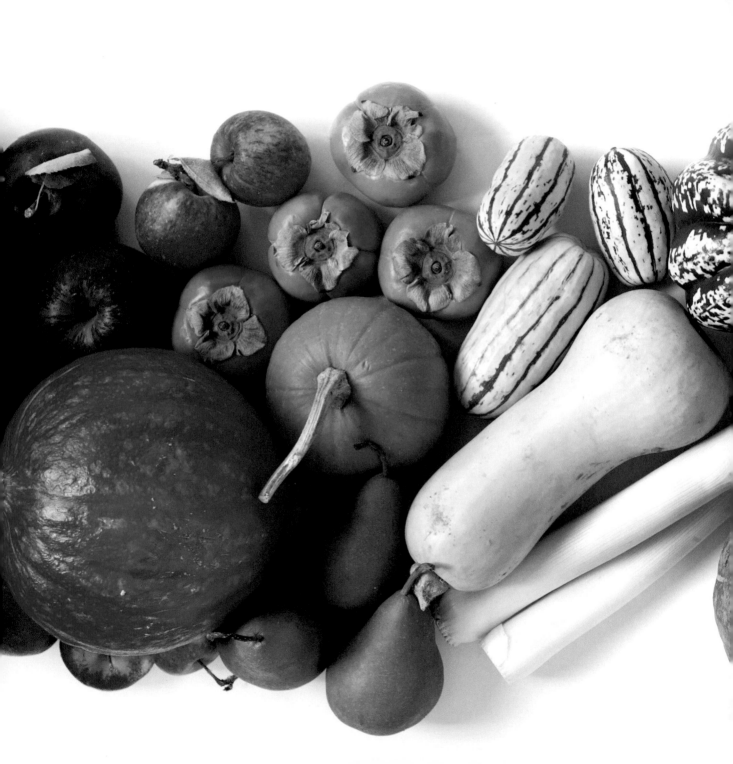

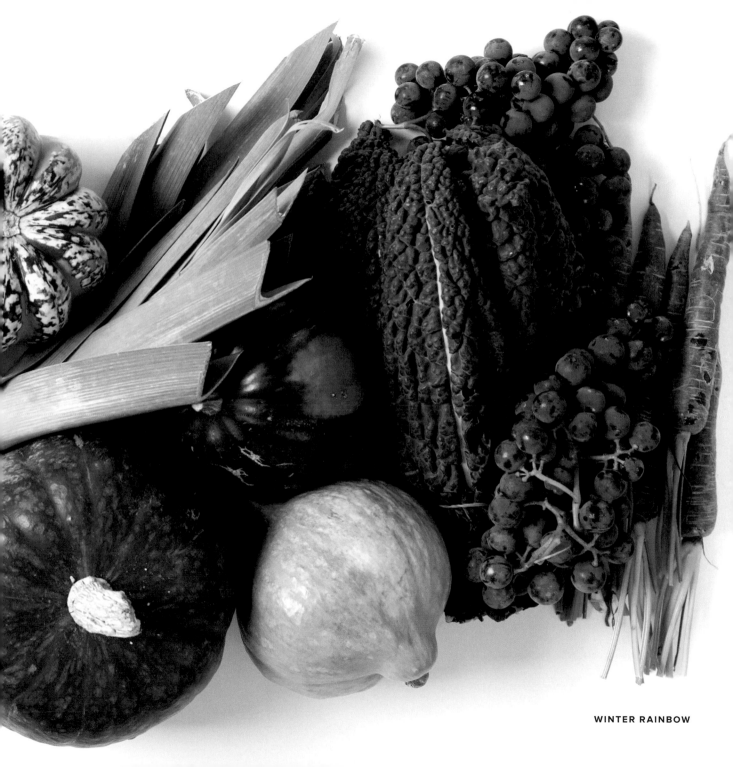

WINTER RAINBOW

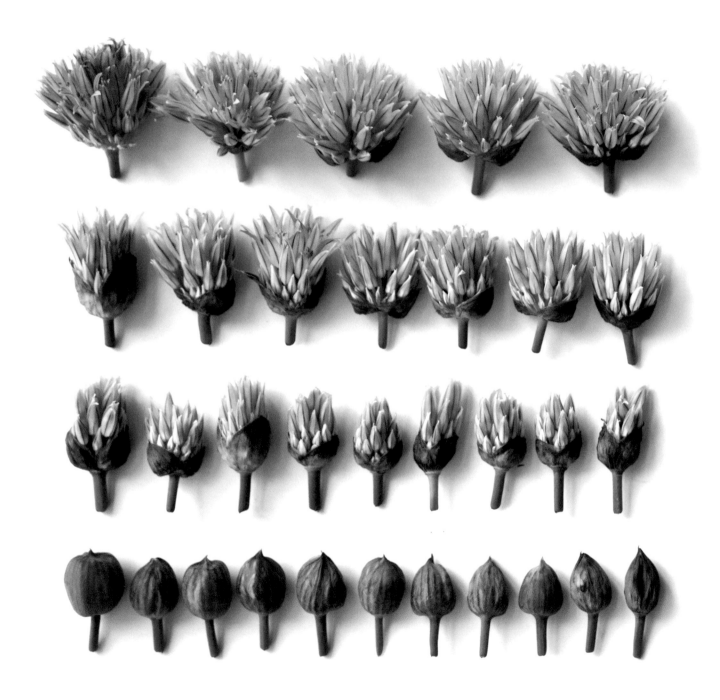

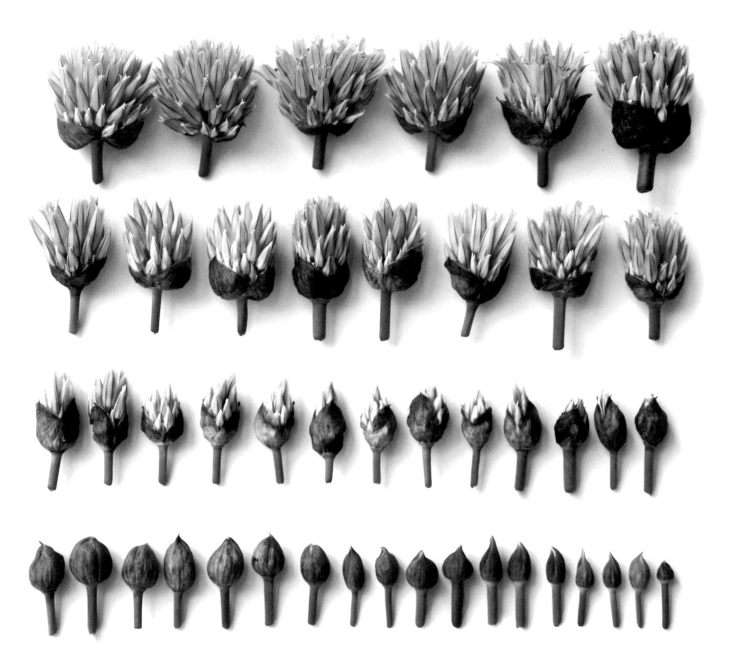

CHIVE BLOSSOMS As they grow and bloom.

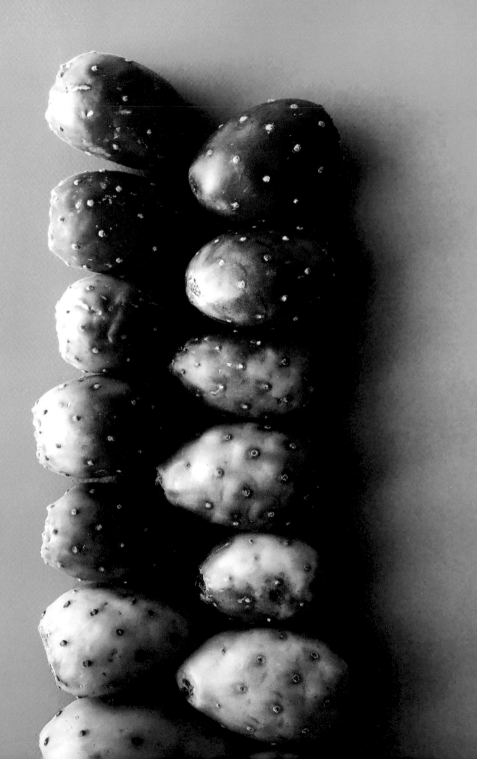

CACTUS PEARS

These beauties grow
on varieties of cactus
and are native to my
hometown, San Diego.
The thorns are quick to
end up in your fingertips
if you're not careful.

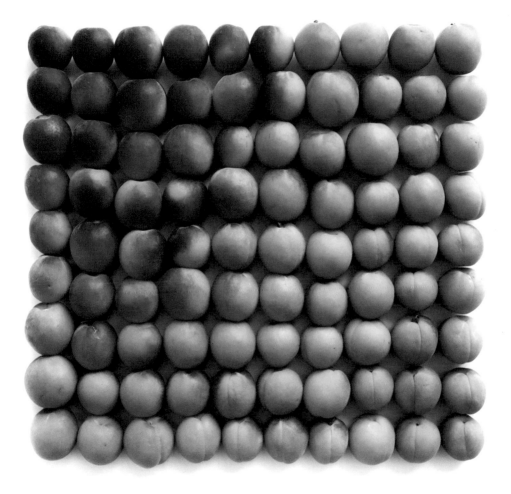

APRICOTS The ripest are at the top left.

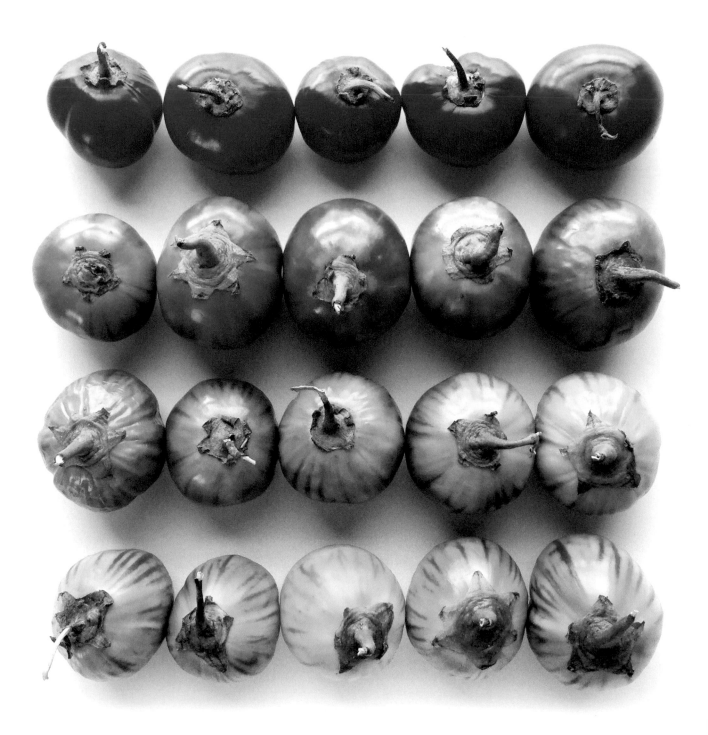

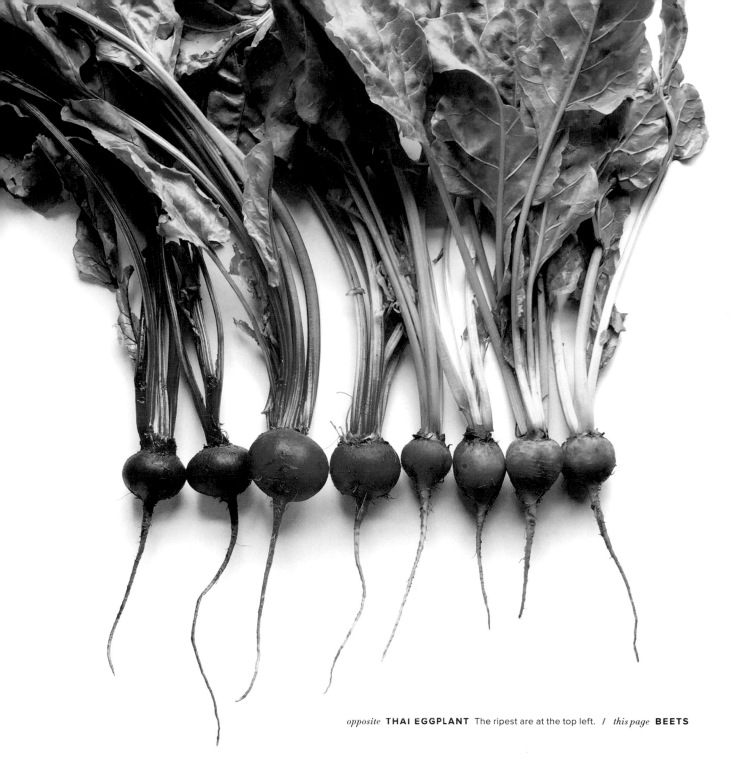

opposite **THAI EGGPLANT** The ripest are at the top left. **/** *this page* **BEETS**

EGGS

One of my best friends, Cricket, takes care of the chickens that created these eggs on Vashon Island, Washington. They're special to me for many reasons and are the most delicious I've come across.

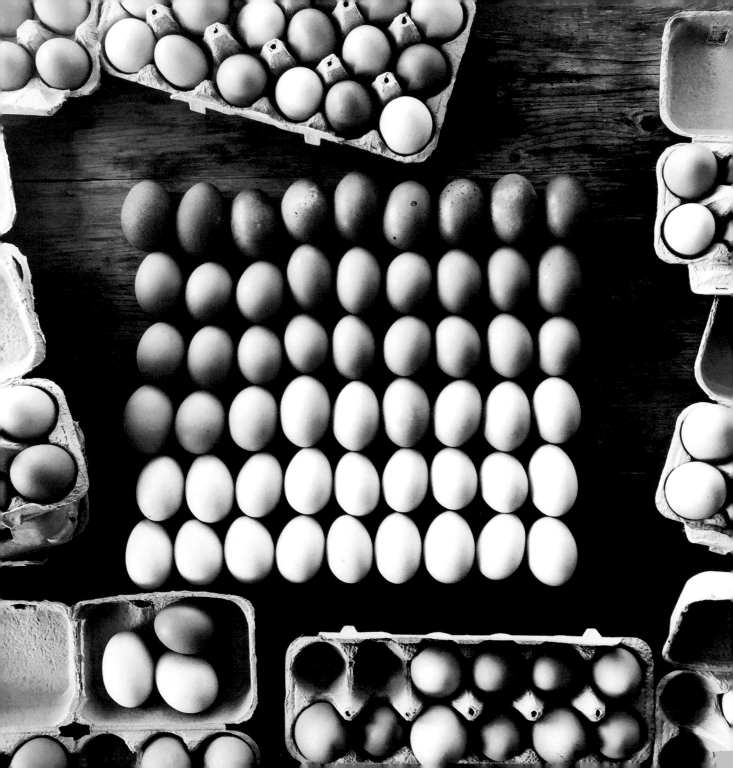

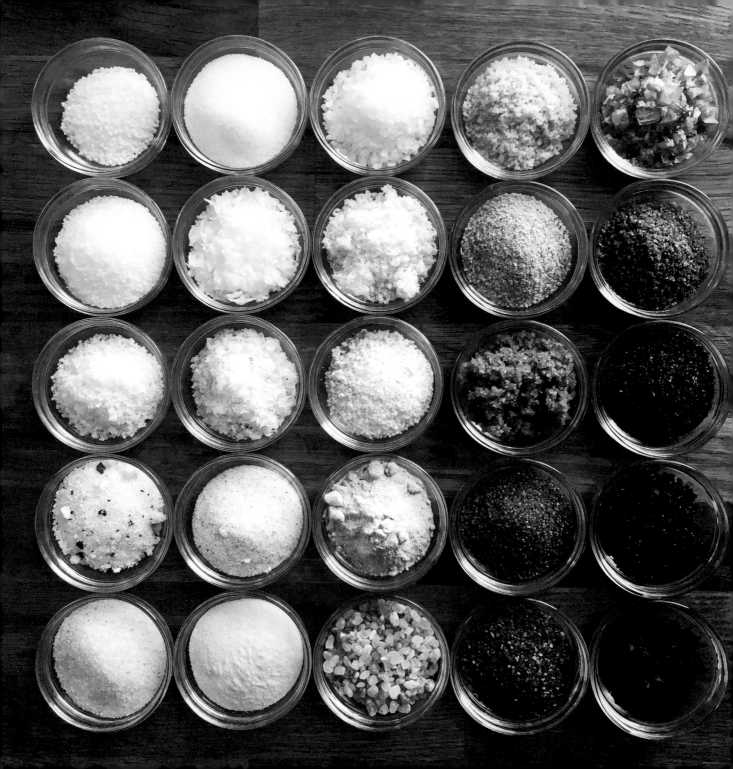

SALT

Left to right, top to bottom pretzel salt / table salt / Italian sea salt / sel gris / smoked Maldon flake / kosher salt / Mediterranean sea-salt flake / lime salt / citrus fennel salt / applewood smoked salt / fleur de sel / vanilla salt / bacon salt / balsamic salt / alderwood smoked salt / truffle salt / natural sea salt / Himalayan kala namak salt / hickory smoked salt / espresso salt / Himalayan pink salt / curing salt / coarse Himalayan salt / Hawaiian alaea salt / black lava flake

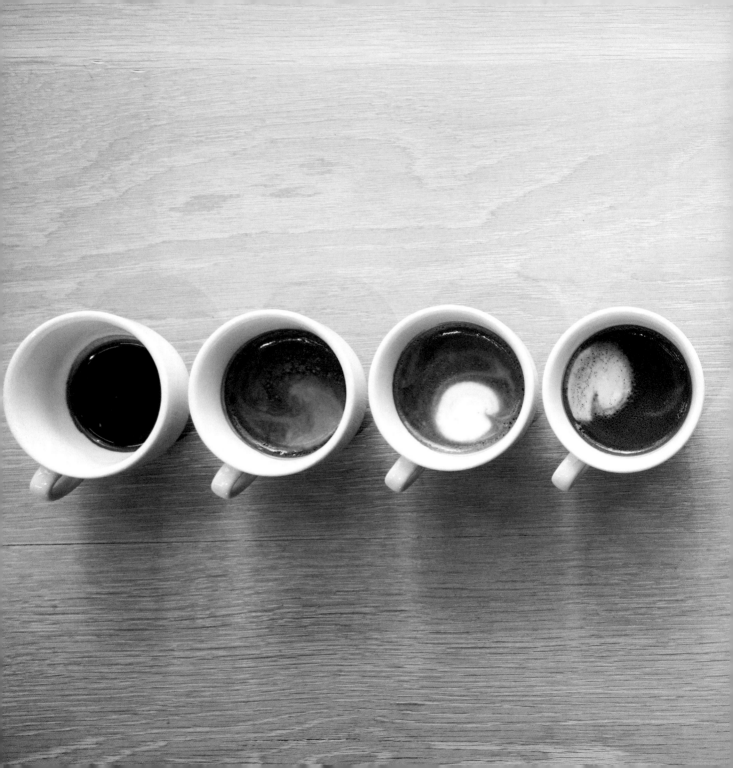

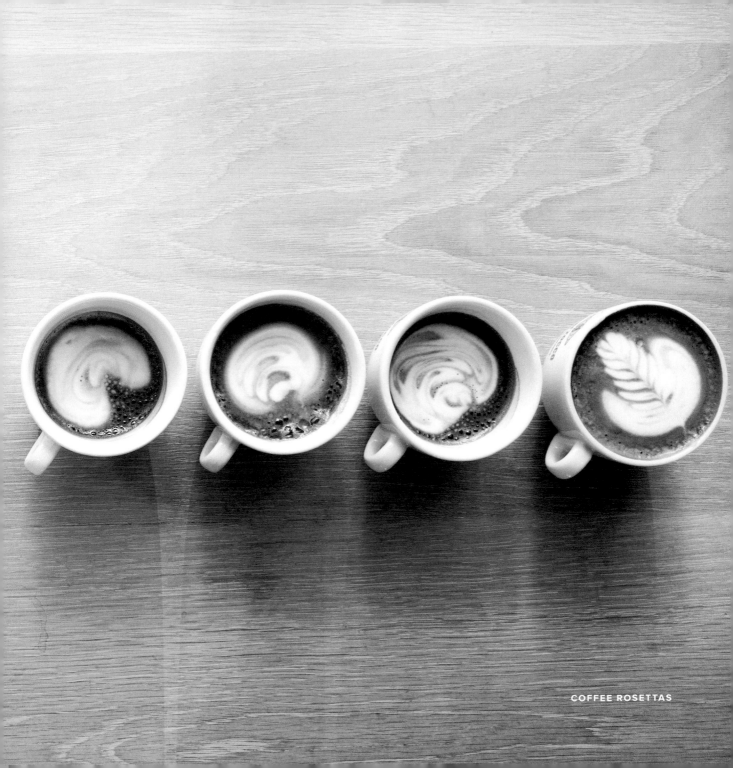

COFFEE ROSETTAS

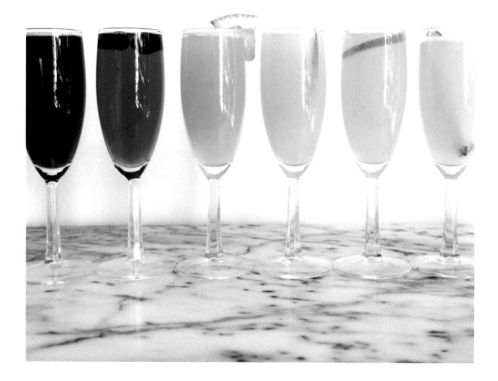

MIMOSAS *From left* with cherry juice **/** cranberry juice **/** grapefruit juice **/** mango juice **/** orange juice **/** pineapple juice

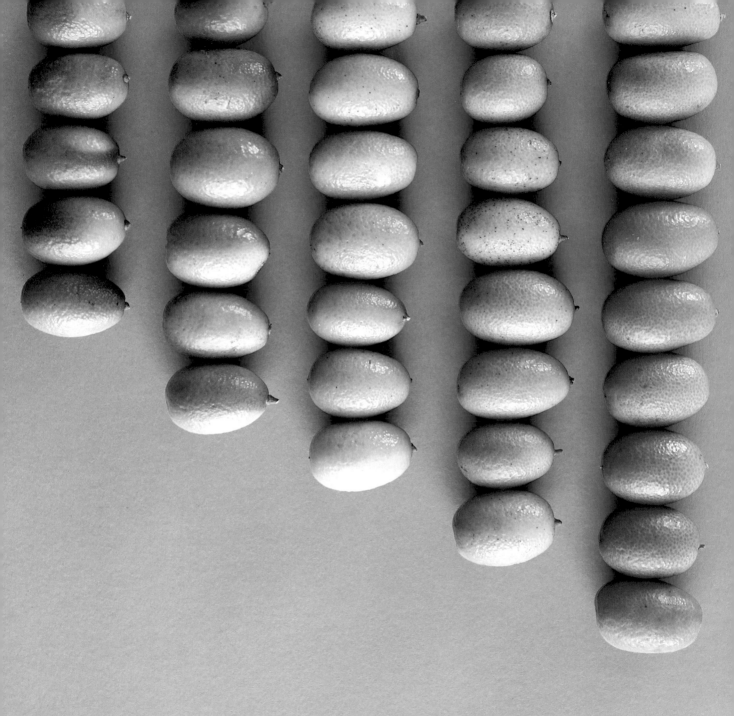

KUMQUATS The ripest are on the right.

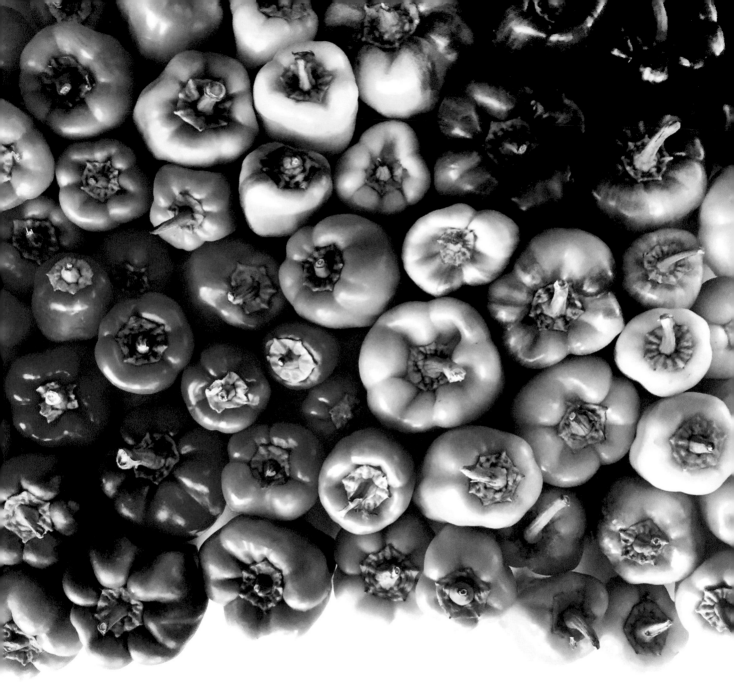

BELL PEPPERS

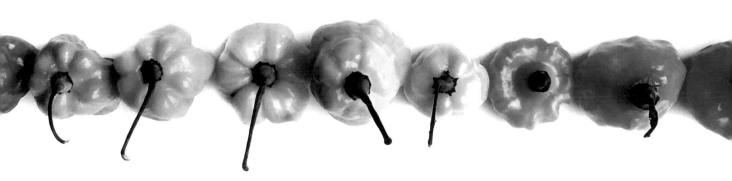

HABANEROS Even the unripe green ones pack a punch.

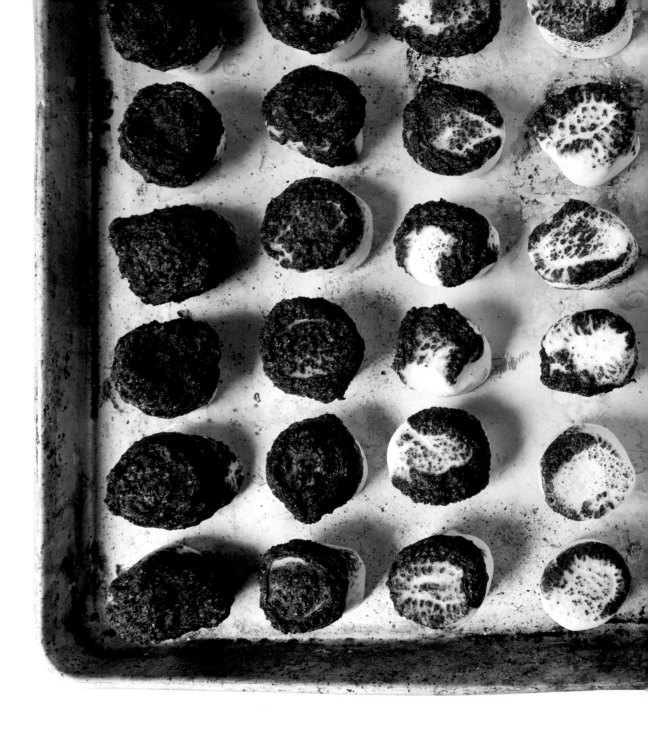

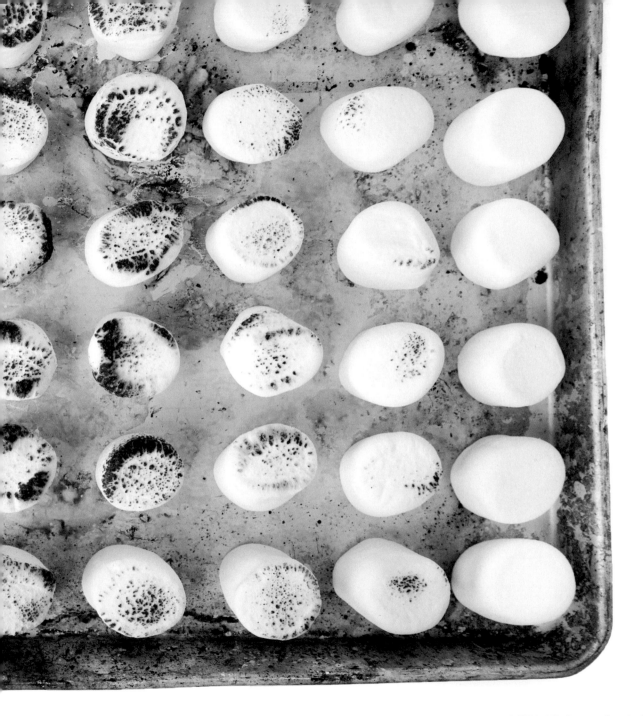

MARSHMALLOWS Which is your favorite for a s'more?

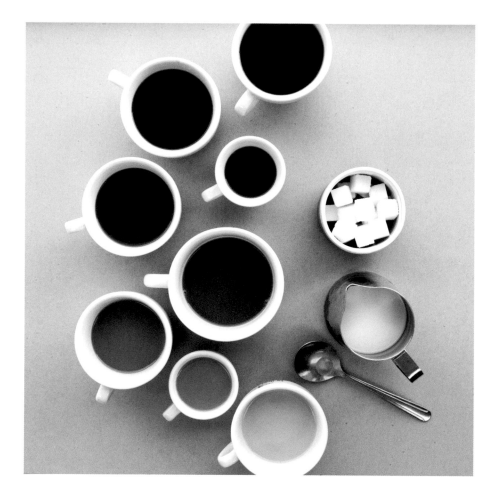

this page **COFFEE AND MILK** Coffee with a splash of milk, or milk with a splash of coffee? / *opposite* **DOUGHNUTS** What dreams are made of.

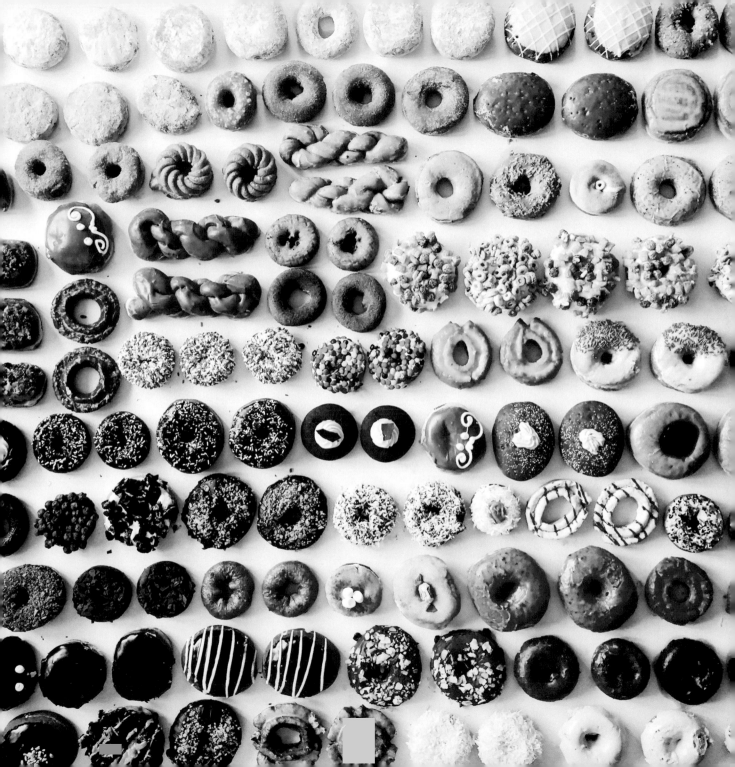

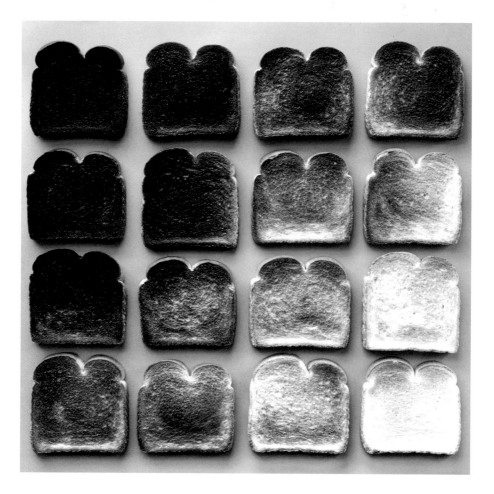

this page **TOAST** Which toast is the best toast? /

opposite **THINGS ON TOAST** And they're all delicious.

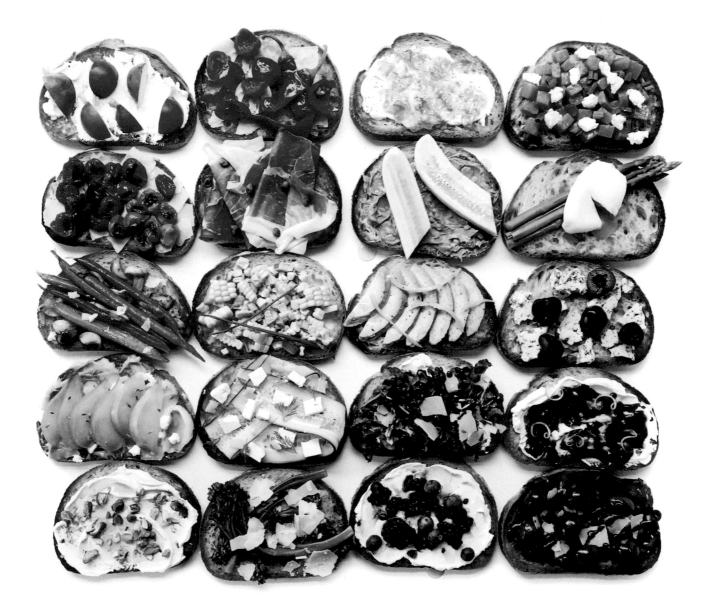

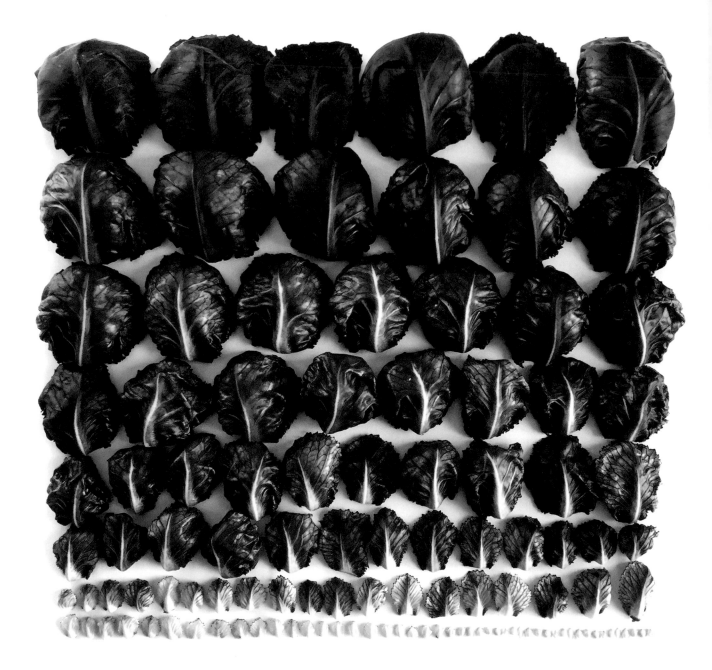

opposite **RED CABBAGE**
Every leaf of a head of cabbage,
from the outside in

this page **TOMATILLO**
The star of salsa verde

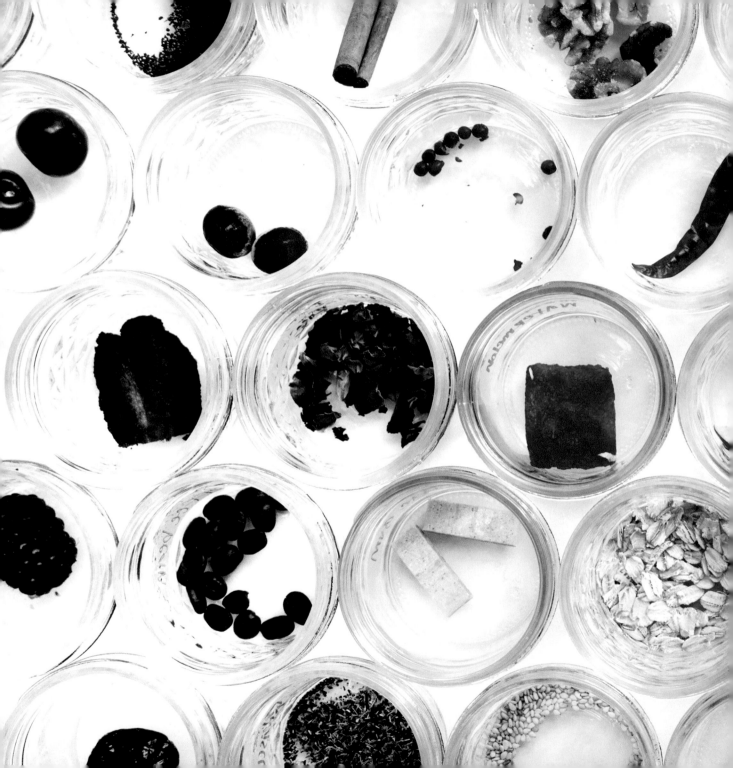

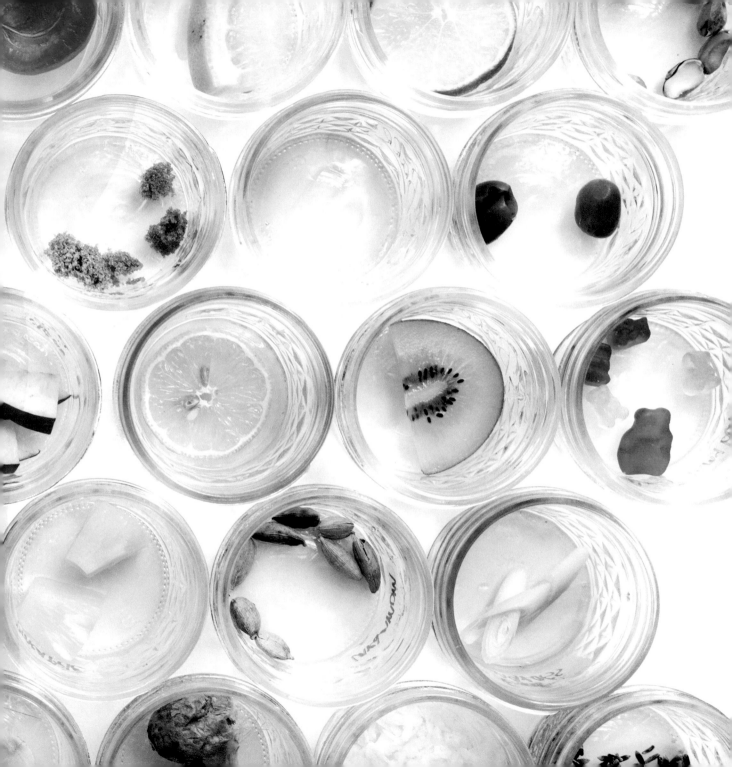

LIQUOR INFUSIONS

previous spread

Infusions enhance the flavor of your favorite liquors. Here, vodka, white rum, and gin showcase the color change within a clear alcohol. Some ingredients do not affect the color very much—but they do affect flavor.

Left to right, top to bottom star anise **/** Earl Grey **/** cinnamon stick **/** walnut **/** apricot **/** grapefruit **/** lime **/** pistachio **/** cherry **/** cranberry **/** pink peppercorn **/** Thai chili **/** brown sugar **/** honey **/** olives **/** bacon **/** rose **/** watermelon **/** apple **/** lemon **/** kiwi **/** gummy bears **/** blackberries **/** coffee beans **/** bubble gum **/** oats **/** pineapple **/** cardamom **/** lemongrass **/** prune **/** hibiscus **/** sesame seed **/** banana **/** ginger **/** coconut **/** lavender

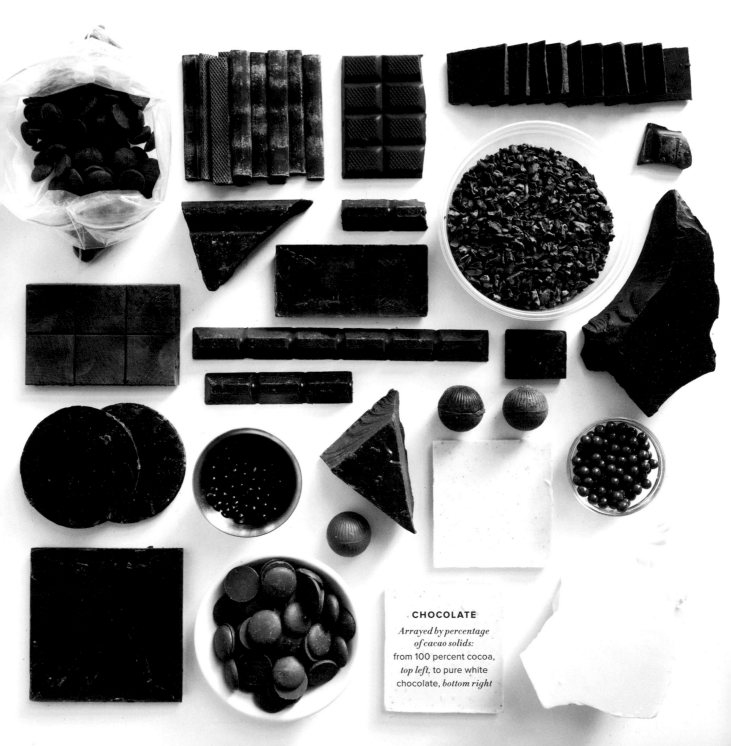

CHOCOLATE

Arrayed by percentage of cacao solids: from 100 percent cocoa, *top left,* to pure white chocolate, *bottom right*

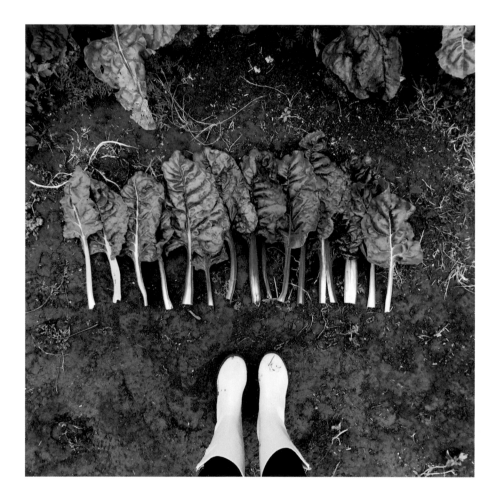

this page **RAINBOW CHARD ON THE FARM** /

opposite **RAINBOW CHARD**

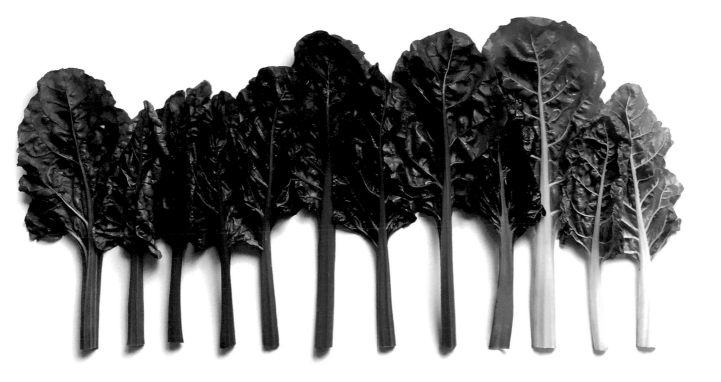

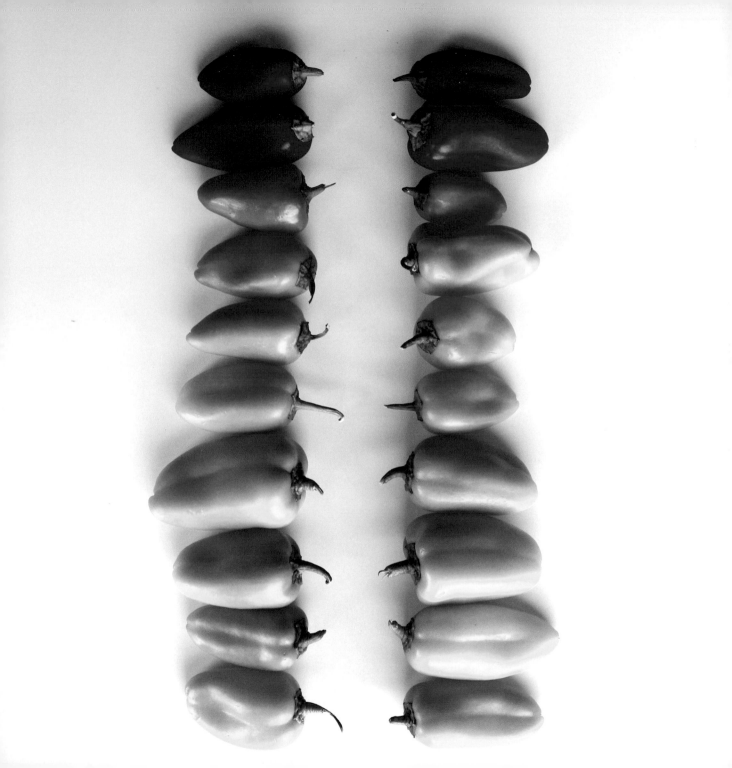

RICE

From right wild rice / sprouted red rice / forbidden rice / Madagascar pink rice / California brown basmati / sprouted short brown rice / short-grain brown rice / California brown jasmine rice / long-grain brown rice / California white basmati / long-grain white / sweet brown rice / white California sushi rice / white Arborio rice / jade pear rice

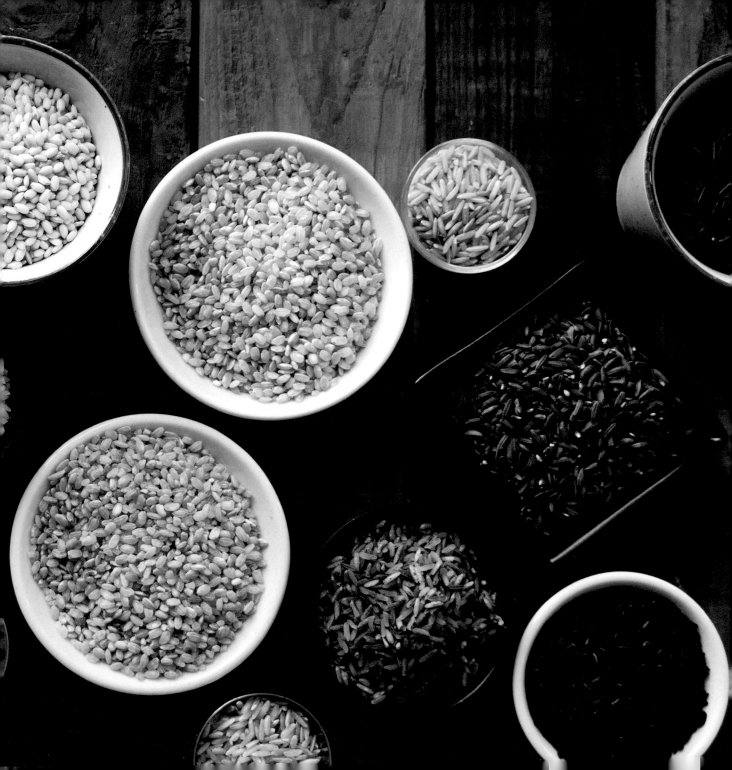

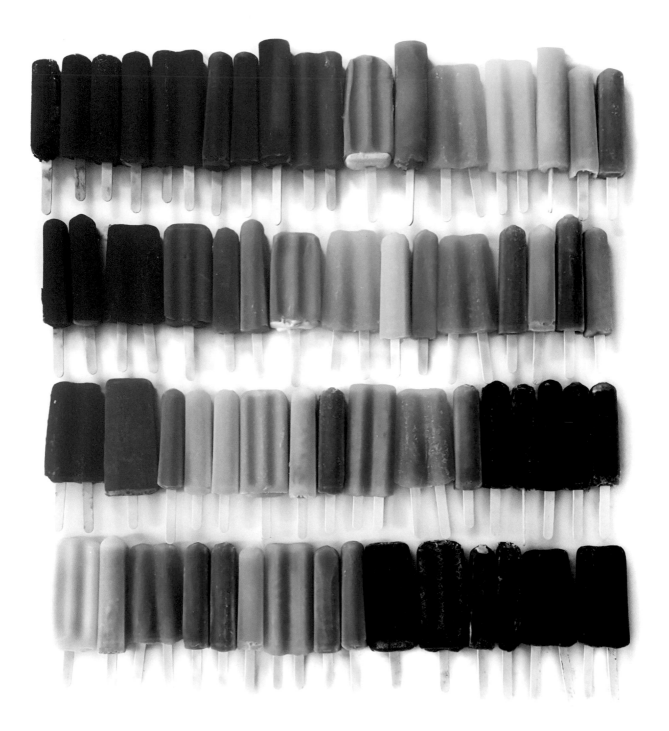

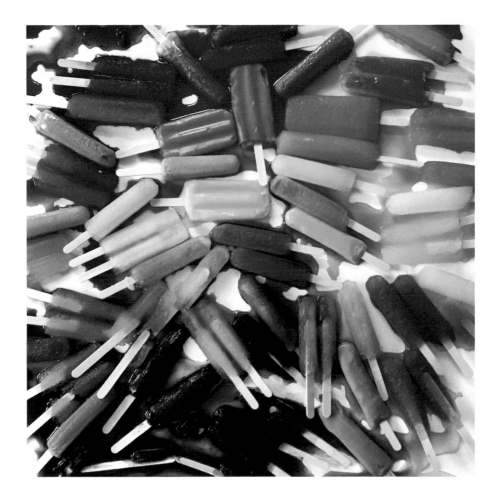

opposite **POPSICLES** Popsicles on a cold day

this page **MELTED POPSICLES** Popsicles on a hot day

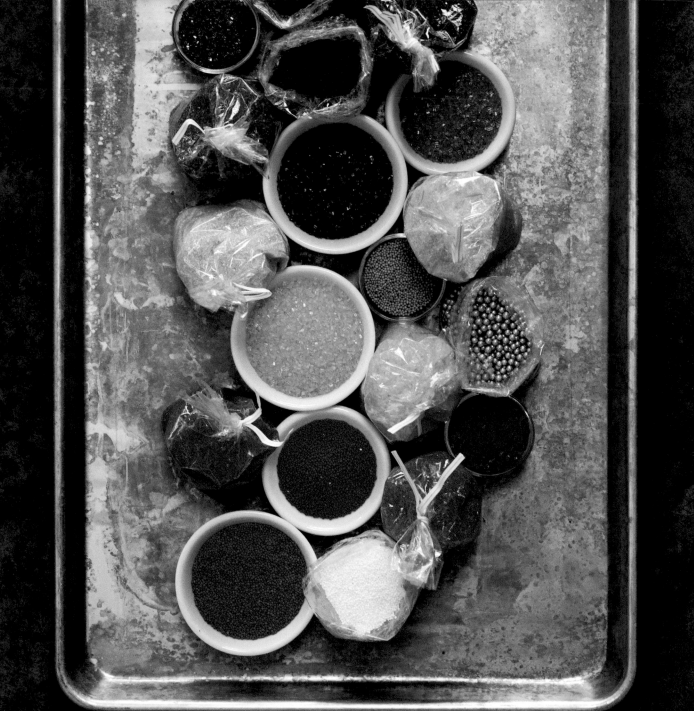

SPRINKLES

⚡

THE BASIC INGREDIENTS OF BAKING

Left to right, top to bottom vanilla bean **/** unsalted and salted butter **/** cream cheese **/** heavy whipping cream **/** milk **/** vanilla extract, cocoa powder **/** corn syrup **/** vegetable oil **/** canola oil **/** baking soda **/** salt **/** baking sugar **/** cornstarch **/** dark brown sugar **/** nuts (pecans and walnuts) **/** light-brown sugar **/** fine cornmeal **/** coarse cornmeal **/** oats **/** sprinkles **/** food coloring **/** sour cream **/** baking powder **/** granulated sugar **/** eggs **/** confectioners' sugar **/** all-purpose flour

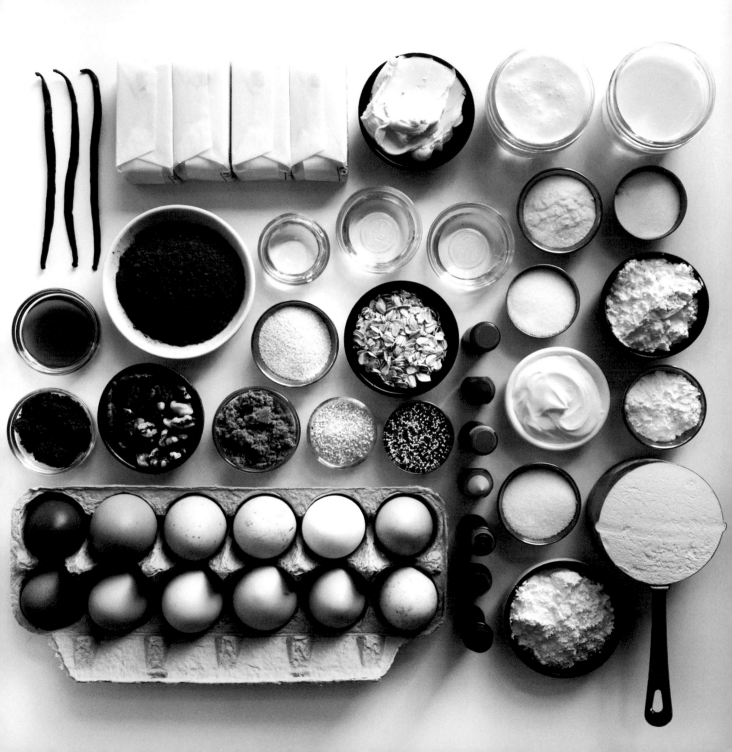

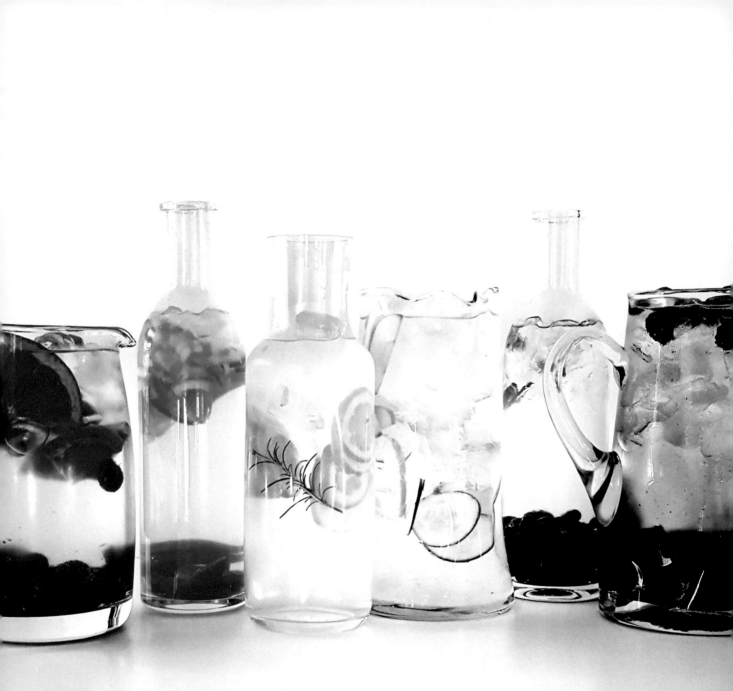

INFUSED WATERS *From left* grapefruit & raspberry /
tangerine & mango / rosemary & lemon / cucumber &
apple / blueberry & mint / blackberry & cherry

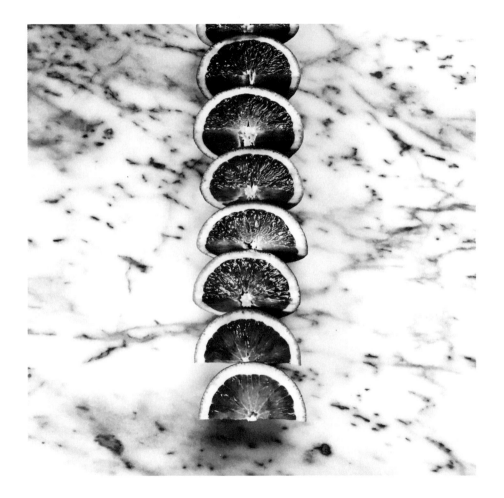

BLOOD ORANGE

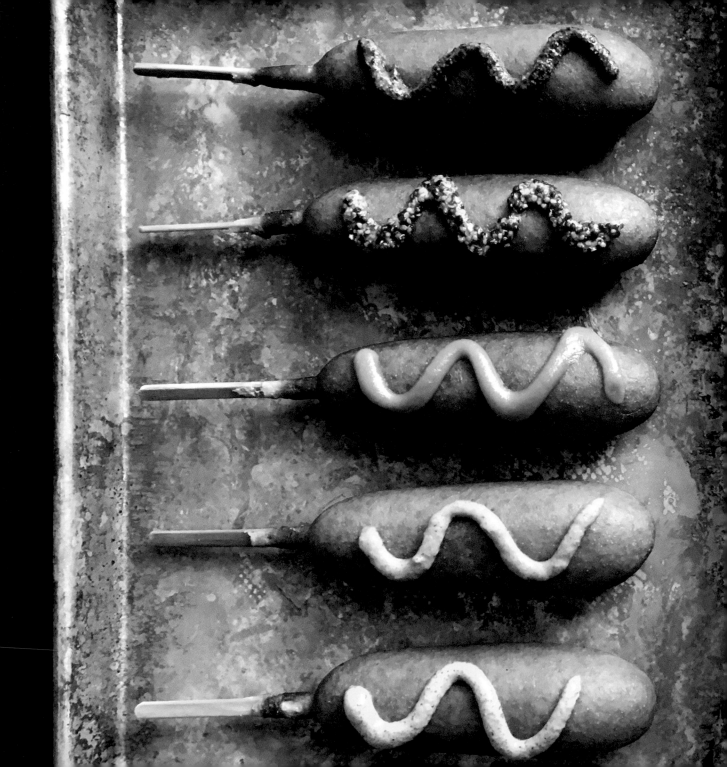

MUSTARD
From whole-grain to Dijon on a dozen
corn dogs . . . minus the two I ate.

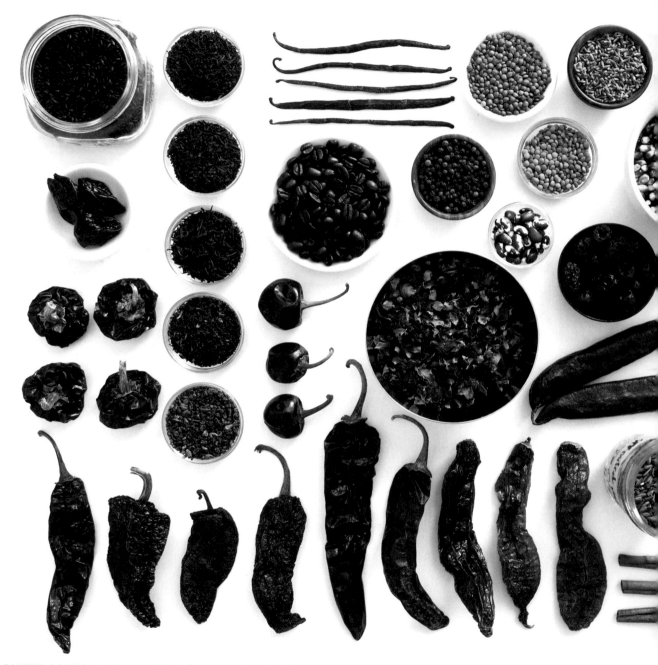

DRIED PANTRY GOODS rice / prunes (plums) / peppers / tea / vanilla beans / coffee beans / rose / beans / lentils / peppercorns / sausage / lavender / popcorn / sprouted farro / cinnamon

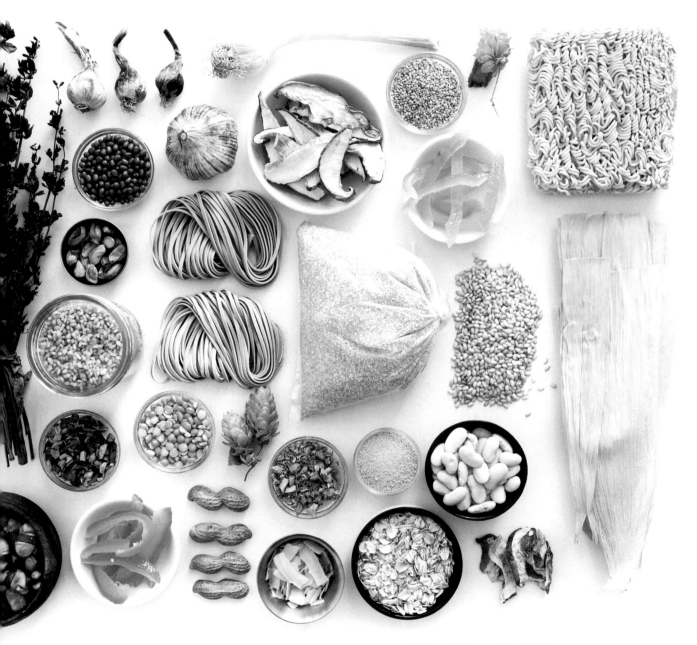

MORE DRIED PANTRY GOODS sage / fava beans / garlic /
mung beans / pistachio / rice / licorice root / orange peel / pasta /
yellow split peas / hops / peanuts / mushrooms / cornmeal / ginger / honey /
coconut / oats / sesame seeds / lemon peel / ramen / corn husk

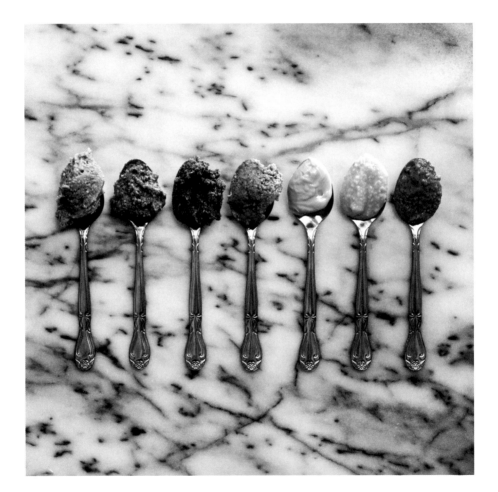

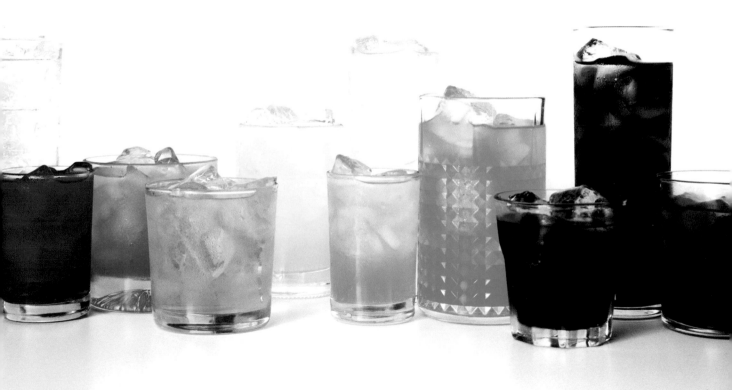

opposite, from left **NUT BUTTERS**

peanut butter / almond butter / hazelnut butter / pecan butter / cashew butter / macadamia nut butter / pistachio butter

this page, from left **SODA**

lemon-lime / strawberry / orange / ginger / pineapple / apple / coconut / blue raspberry / grape / cola / root beer

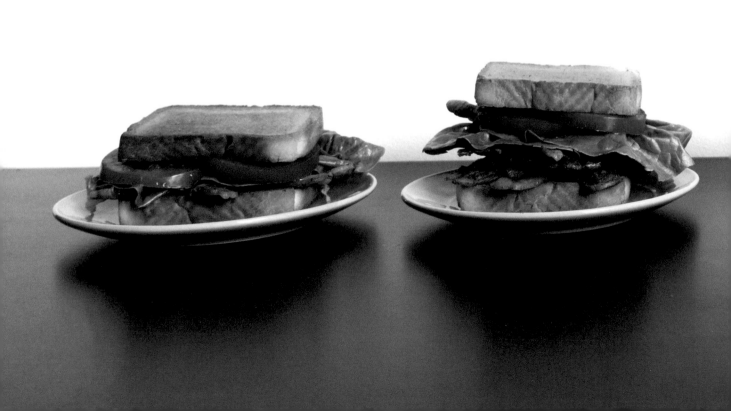

BLT

More like a BBBBBBBBBBBBBBLT.

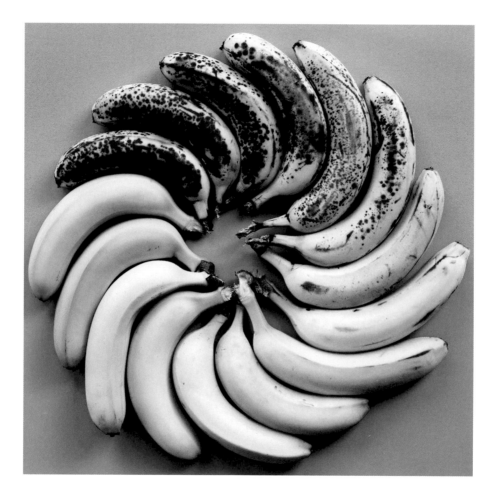

BANANAS If this were a clock, my ideal banana
would be somewhere near 5:00.

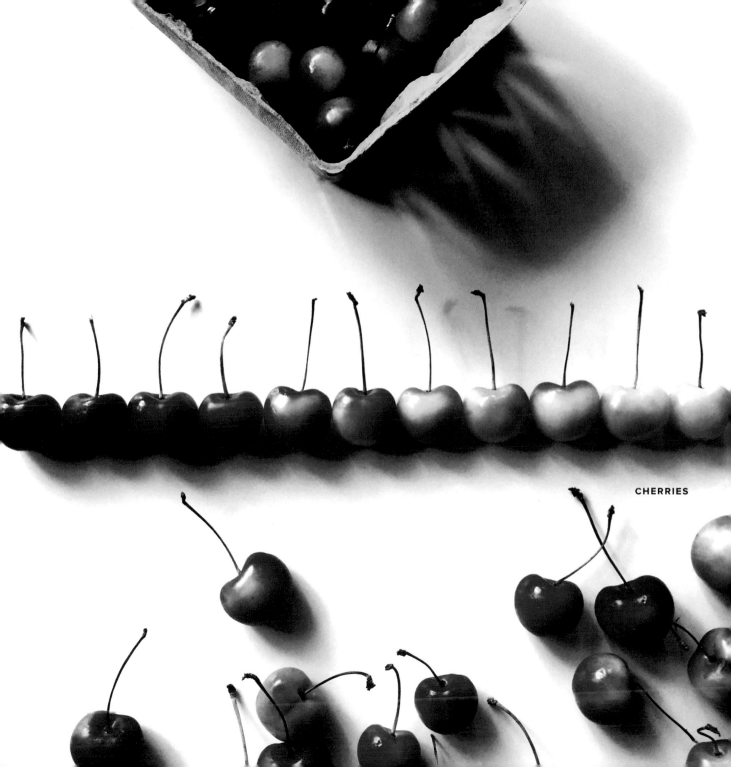

CHERRIES

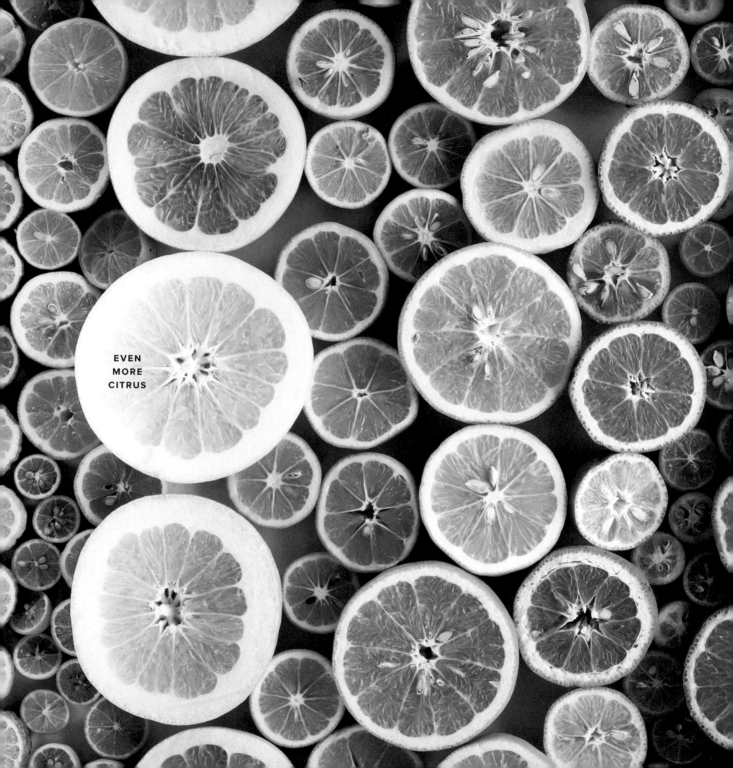

EVEN
MORE
CITRUS

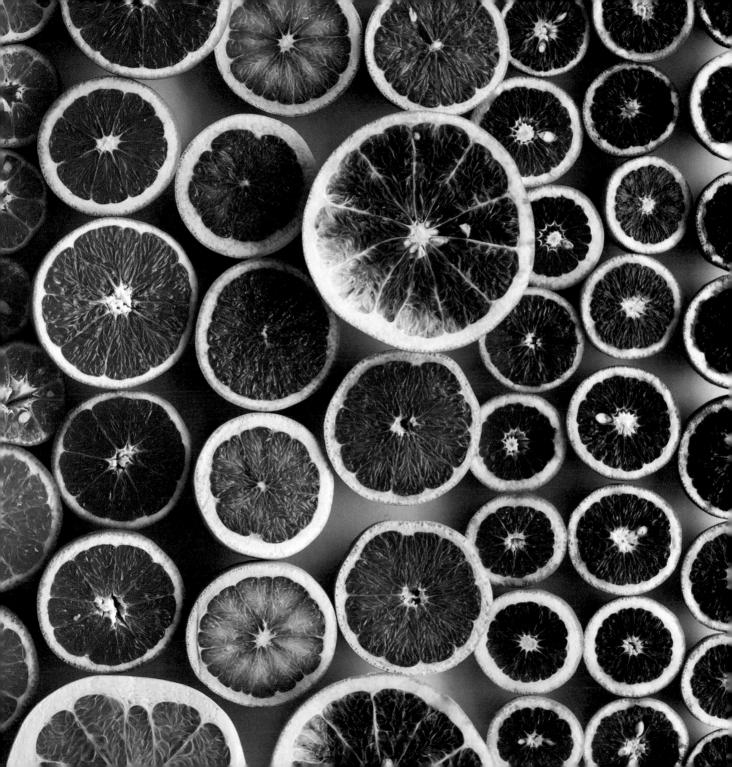

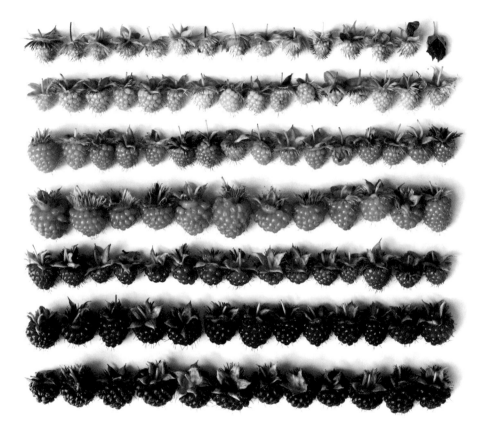

SALMONBERRIES Salmonberries are a fruit in the rose family that ripens in Alaska and the Pacific Northwest from May through July. Blossoming first with flowers, the fruit eventually grows to resemble a raspberry. They are best eaten in their golden or dark-red varieties—the fourth and seventh rows.

⚡

ALL THE COLORS UNDER THE SUN

following spread

Left to right, top to bottom plums **/** Merlot Parmesan **/** tomatoes **/** strawberries **/** red hots **/** plum **/** apple **/** green Jell-O **/** pepitas **/** edible flowers / beet hummus / watermelon **/** edible flowers **/** Rainier cherries **/** variegated lemon **/** green cauliflower **/** pear **/** turnip **/** radicchio **/** pearl onion **/** shallot **/** bell pepper **/** edible flower **/** lemon **/** endive **/** red cabbage / pearl onions / purple Jell-O / purple cauliflower / chipotle powder / mango / papaya / lemon / sweet pepper / lime / yellow Jell-O / bee pollen / yellow zucchini / edible flowers / grapes / chia seeds / red bananas / shallot / coconut / carrots / apricot / pluot **/** lentils **/** caramel corn **/** banana

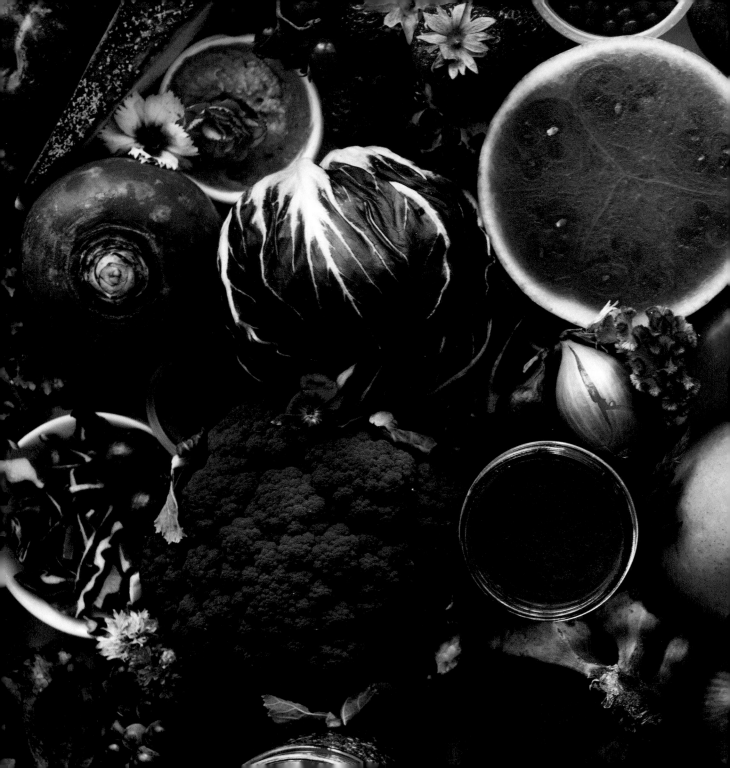

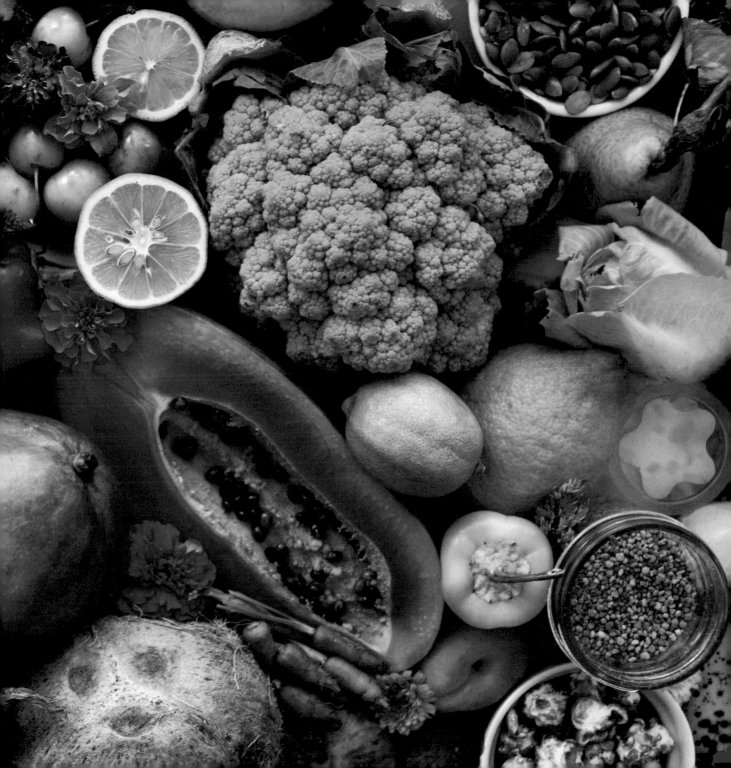

ACKNOWLEDGMENTS

THANK YOU TO

Oxbow Farm / Helsing Junction Farm / Local Roots Farm / Hogsback Farm / Seattle Farmer's Markets / Samsung Mobile USA / La Marzocco / Eileen Mandell / Danielle Cullins / Linda Miller Nicholson / Chris Ziemba / Grace Lee / Nick Lavalle / Cricket O'Carrol / Michael Szczerban / Ashley Collom / the Luikart family / the Hildebrand family / Café Presse / the worldwide online community that supports my art and process.

ABOUT THE AUTHOR

Brittany Wright sees food as an art, and an opportunity to do something creative. In the process of working on her life goal to teach herself how to cook everything and anything, she found the beauty behind what we eat.